Circumstances Alter Photographs

CIRCUMSTANCES ALTER PHOTOGRAPHS

Captain James Peters' Reports from the War of 1885

Michael Barnholden

 TALONBOOKS

© 2009 Michael Barnholden

Talonbooks
Box 2076, Vancouver, British Columbia, Canada V6B 3S3
www.talonbooks.com

Typeset in Minion and Meta. Printed and bound in China.

First printing: 2009

The publisher gratefully acknowledges the financial support of the Canada Council for the Arts; the Government of Canada through the Book Publishing Industry Development Program; and the Province of British Columbia through the British Columbia Arts Council and the Book Publishing Tax Credit for our publishing activities.

LIBRARY AND ARCHIVES CANADA CATALOGUING IN PUBLICATION

Barnholden, Michael, 1951–
 Circumstances alter photographs : Captain James Peters'
reports from the war of 1885 / Michael Barnholden.

ISBN 978-0-88922-621-0

1. Riel Rebellion, 1885. 2. Riel Rebellion, 1885—Photography.
3. Riel Rebellion, 1885—Campaigns—Pictorial works.
4. Peters, James, b. 1853. 5. Photographers—Canada—Biography.
6. Canada. Canadian Army. North-West Field Force—Officers—
Biography. I. Title.

FC3215.B375 2009 971.24'202 C2009-902880-8

CONTENTS

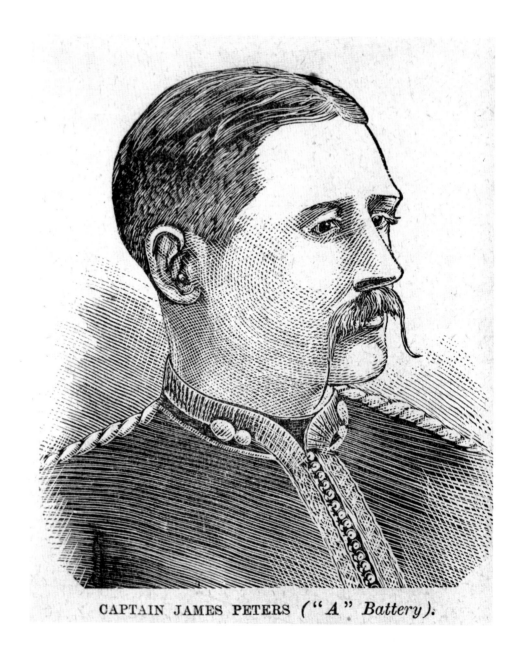

CAPTAIN JAMES PETERS ("A" Battery).

Sketch of Captain James Peters.

Glenbow Archives NA-2483-13.

INTRODUCTION

Spring was late in coming to the prairie. There was still a skim of ice on the water pails in the morning and any rain was often mixed with snow. The steamboats from Swift Current were slowed by low water; the flood crest of the South Saskatchewan was still some weeks away. On the morning of Thursday, April 23, 1885, the North West Field Force was finally on the move.

Captain James Peters of Battery "A," Royal Canadian Artillery, had already detailed the hardships of train travel around the north shore of Lake Superior in his column as a special correspondent for the *Quebec Morning Chronicle*. His latest report had been mailed on Sunday, April 19, as the troops waited for re-supply and reinforcements, telling of their long stay at Clarke's Crossing where the Dominion Telegraph line crossed the South Saskatchewan River.

The North West Field Force under the command of General Frederick Dobson Middleton had been split into three distinct units. The main force under the general's command—including Captain Peters—had advanced by forced march from Qu'Appelle (formerly Troy) on the Canadian Pacific Railway (CPR) mainline to Clarke's Crossing, 196 miles, in under ten days. Not bad for the fresh militiamen who had only recently been clerks and farmers in Ontario, Québec and the Maritimes. Many of them had never been under fire and were being trained as they marched. Their enthusiasm for battle was premature, in Peters' eyes, given their distinct lack of experience. Even a poorly equipped, badly trained enemy force could inflict severe damage almost incidentally on troops who were equally unprepared. However, Peters was not too worried this morning; he was glad to be on the move and looked forward to engaging the rebels. If he'd had his way, they would not have waited so long, their insufficient training notwithstanding.

While waiting at Clarke's Crossing, Peters had had time to think about strategy and tactics. He concluded it would be best not to split the command into two columns, one on either side of the river, but rather to march directly to Batoche and confront the rebels in their stronghold. He wanted a show of power—the nine-pounders bombarding the rebels, covering the troops as they moved in on the disorganized, poorly equipped Métis hunters. He had yet to see a man of the Northwest Territories who could outshoot the rawest recruit, even if somehow they had obtained rifles that were equivalent to the North West Field Force's

Snider Enfields and the new Winchester repeating rifles. The troops had enough ammunition to rain lead on any resistance they encountered.

The men were bored and itching for action. They could not understand Middleton's reluctance to engage what they considered an obviously inferior enemy. He seemed to think only his hand-picked British officers were worth listening to. The Canadian lads and their officers had heard him disparage their abilities once too often; they'd show the old fool. Hadn't they marched as well as any British troops? Maybe better, considering the landscape they'd crossed with its lack of water and wood, and the weather they'd shrugged off. The scouts had been deployed for days and had not seen anything worth reporting, other than the three Sioux who'd been arrested, having been surprised in their camp as they were making their way to join the rebels.

On Thursday, they had marched from Clarke's Crossing to McIntosh's farm. Looking around, Peters could not understand why men from such prosperous residences would take up arms. Indeed, why would citizens take up arms against their government, especially prosperous farmers with good land and bright futures? Although the white settlers had parted company with their Métis compatriots when it came to taking up arms, their grievances were exactly the same as those of their neighbours. Everyone present in Canada's Northwest could see the plight of the Indians and Métis, and well understood that Prime Minister John A. Macdonald's "National Policy" was not for their benefit.

The militiamen were more than ready as they broke camp and prepared to march off north toward Batoche's Crossing and a meeting with the enemy. They'd show the rebels, they'd show Middleton, and they'd show the country and the world what good stout Canadian men were made of. They weren't afraid of anything, let alone an enemy they had yet to see.

Middleton and some of Colonel Boulton's scouts had gone on ahead and sighted mounted men in the gullies of Fish Creek (Tourond's Coulee, as the Métis called it). The trail led down into the heavily treed creek bottom, across the stream and up the other side, back onto the prairie. The horsemen immediately melted into the trees. The scouts had not quite entered the coulee in pursuit when all of a sudden they heard bursts of gunfire crackling from the dense foliage. They could no longer see the enemy fighters—the scouts had ridden into an ambush and were trapped on the open trail. Those not killed or wounded in the first barrage headed back the way they had come to warn the troops, but it was too late. At the first sound of gunfire, the militiamen had been rushed into place at the rim of the coulee, where they stood out against the prairie sky—easy targets for the riflemen hidden in the dense bush below. The cannons were brought forward and limbered up, but they could not fire down into the depression. The best they could do was fire over the coulee and prevent the enemy from leaving.

> About 11 o'clock yesterday, as we were marching gaily along through the first really fairly wooded country, we suddenly heard a volley in front and almost five minutes afterwards the General sent for the guns, so up we went to the front. (Peters)

The Canadian Army's first action in the War of 1885 had been to walk straight into an ambush. The militiamen kept throwing themselves at the hidden enemy. They crawled forward to the edge of the coulee, stood to charge, and were picked off like black birds against the grey sky. This went on all day; unsuccessful sortie after sortie was made. Peters' own troops were decimated in an ill-advised rush that exposed them to withering fire. The Métis warriors held their ground, whooping each time they saw a fresh kill. The cannon were useless, firing over the coulee, destroying an unoccupied house and a copse of trees where some of the Métis fighters had hidden their ponies.

As the cannon roared and nine-pound lead balls flew through the air, Peters unpacked his Marion Academy camera that he had loaded with twelve dry, glass quarter-plates the night before. Holding the camera in his hands, with his lens set for infinity, the exposure time would be short enough that he could shoot from horseback. The Métis were firing right at him when he took his first "instantaneous" photograph of the day—this was the world's first photograph taken under fire.

By late afternoon, the troops on the other side of the South Saskatchewan River— Middleton had divided his force in two, a strategy Peters disagreed with—who had heard the rifle and cannon fire but couldn't see what was going on, had been ordered to rejoin the main column, but that would take the rest of the day if all went well. Middleton had no choice. He ordered a retreat. The troops fled back to the bare prairie with their wounded and dead and gathered behind their hastily assembled wagons in a rough enclosure. Guards were posted and the men settled in to contemplate Middleton's failed strategy. Snow and a general alarm just after midnight made for a poor sleep. The Canadian Army had suffered its first check at Fish Creek. Captain James Peters had taken the world's first battlefield photographs under fire. His historic dispatch from the front would have to wait until the following day. It would still be in time for the next mail packet.

Special Correspondent

When explorers—who were variously trade emissaries, land developers, mining promoters— made their way to this world new and unknown to them, part of their job description included bringing back "the news." Taking the form of maps, journals, samples of the flora and fauna both living and dead, sketches of anything of interest, including living beings, the news was mostly for the benefit of their sponsors and financial benefactors, be they investors or royals hoping to extend their mercantile or imperial reach. The news could appear as publications, as paintings, as exhibits in zoos and museums or on stage, and was primarily used to build support and acquire backing for future ventures. This form of reportage was often critical to the undertaking; the map-maker and artist were valuable members of any expedition.

 As drawing and painting were the dominant art forms in the colonial era of the eighteenth and early nineteenth centuries, it is not surprising that the colonial subject also became the principal subject of those art forms. Explorers' sketches were turned into large oil paintings that reflected and reaffirmed the predominant sentiments of the audience for which they

were intended. If art can be seen as an expression of the sensibility or ideology of the day, surely the sketch was a means for the technological exploitation of the subject—current technology put to the service of the motivating impulse. If imperialism and exploitation were the reasons for exploration, then art was deployed in their service, as surely as maritime engineering had progressed to allow a regularized sustainable sea voyage previously unimaginable, but essential to the colonial project.

The artist Paul Kane visited what would become the Canadian West from Toronto in 1846, returning with some of the first images of what he perceived as "the great lone land," and a journal in which he recorded what he saw. He describes the area around Fort Carlton just north of Batoche as "situated between the wooded country and the other plains … it presents more the appearance of a park; the gently undulating plains being dotted here and there with clumps of small trees" (Kane). His trip was sponsored in part by the Hudson's Bay Company (HBC) and many of the company's principals bought his sketches and finished oils. Kane travelled to London and had his journals published in book form the next year. *Wanderings of an Artist among the Indians of North America from Canada to Vancouver's Island and Oregon through the Hudson's Bay Company's Territory and Back Again*, was beautifully illustrated with many lithographs of his work. The book was an immediate success and by 1863 had appeared in French, Danish and German editions. Within a generation, the Canadian Northwest would no longer look the same, as "civilization" reached into the heart of the North American continent and irrevocably changed almost everything in its path. Post-contact literature and art, such as the correspondence and photographs of James Peters, constitute a public record of that transformation in a new technological medium, and changes forever the public perception of the colonial subject.

While sketching and painting remained the dominant forms of image production in the pre-contact era of North American colonialism, by the 1860s photographic studios were present in most cities and towns throughout the settled areas of Canada and the United States. Portraiture in the form of calling cards—"cartes de visites" later superseded by "cabinet portraits"—larger images that could be displayed on a cabinet—were fashionable accoutrements available to the emerging middle classes. Soon, cameras carried by professionals were crossing the country mainly by train, as rail transportation began to spread the reach of "civilization." But the requirements for preparation of the wet plates used in early photography still required that photographers construct and transport substantial portable darkrooms.

The Crimean War of 1853–56 and the American Civil War of 1861–65 are generally regarded as the first wars to be documented with photographic images. However, the equipment was so cumbersome and the plates necessitated such long exposure times that it was impossible to photograph action. What is generally referred to as early battlefield photography comprises photographs of battlefields after the action has taken place, leaving open the possibility that scenes were specifically arranged or rearranged to suit the "message" the photographer was attempting to construct for the public.

Photographic technology eventually advanced to the point where "naturalist" or "detective" cameras, such as the Academy Camera produced by the Marion Company of Soho

Square in London, England, which came on the market in 1883, could be carried, along with a dozen prepared glass plates, in a leather box slung over the photographer's shoulder. The faster shutter speed of these cameras allowed for hand-held photography. Thus, a tripod was no longer necessary to stabilize these cameras. Since they used the new pre-coated plates that required no preparation other than loading them in darkness—and which could be stored for later development—suddenly the only physical restriction on a photographer creating photographic images was access to the action.

Peters, the well-trained soldier that he was, did not express a personal opinion about the legitimacy of the campaign in which he served. However, the historical subjects he recorded during that campaign, in both image and text, are telling.

The Métis and Indians, as well as the white settlers—mainly farmers and merchants from Ontario who had settled in and around Prince Albert in anticipation of the growth of the "fertile zone" along the river valleys of the Northwest Territories of Canada—had a lot to be angry about. The Hudson's Bay Company, the Canadian Pacific Railway, the North West Mounted Police (NWMP), the North West Council, the land settlement companies and the faraway federal government in Ottawa: all were subjects of much consternation for the residents. The HBC continued to act as a monopoly, the CPR ignored the needs of the peoples of the Territories in order to reward their friends, the North West Council was stacked with supporters of the HBC and CPR, while the NWMP enforced laws that were unjust and unfair to the locals. Settlement companies drove out "squatters" while the federal government refused to address the land question. A decade's worth of Métis and Indian petitions demanding representation, rights and settlement of the land question had achieved nothing. Whether they were manipulated by Louis Riel using his religious and spiritual standing in the community, as Tom Flanagan suggests, or conspired against by Sir John A. Macdonald and his Conservative Party using Hudson's Bay Company employee Lawrence Clarke as an agitator (McLean), their anger spilled over near the end of a long, hard winter in 1884–85 when a large group of disaffected Métis citizens declared a new nation with a provisional government by and for the Métis population of the south branch of the Saskatchewan River, selected a flag, elected a council (called the Exovedate) with powers of search and seizure as well as arrest, and formed a military made up of a standing army with experienced cavalry recruited from the ranks of buffalo hunters and allied Indians. The hand-written document "Justice commands to take up arms" that became the Declaration of the Provisional Government signed by the Exovedate on March 21, 1885, finally got the attention of the Canadian government in Ottawa (Charlebois, 142), but not the kind of action that the new nation had hoped to achieve with their Declaration:

> On the 23rd of March, at 2 P.M., I was informed by the Minister of Militia and Defence, Mr. (now Sir Adolphe) Caron, that the French half breeds under Riel, the well known rebel who had been driven out of Manitoba by Lord Wolseley in 1870, were causing such trouble in the North West Territories as would necessitate military action, and that the Premier, Sir J. Macdonald, wished me to start as soon as possible for Winnipeg. (Middleton, 4)

Métis Council minutes, St. Antony, March 21, 1885.
Library and Archives Canada.

When General Frederick Middleton arrived in Winnipeg at 7:00 A.M. on March 27, 1885, after three days and nights travelling as a civilian on the train through the United States, he was greeted with the news that on the previous day a party of North West Mounted Police and volunteers had been defeated by a large force of Métis soldiers, with twelve killed at Duck Lake in what appeared to be an ambush. It seems to have been a terrible misunderstanding—a hot-headed, trigger-happy NWMP scout had fired on Métis peace emissaries during a parley. Nonetheless here, finally, was the "evidence" of "rebellion," and the justification for war. Middleton resolved to leave Winnipeg that very day by train for Qu'Appelle, taking with him the Winnipeg Militia (Middleton, 4). As general officer commanding, he was in charge of the Canadian Militia and all of the forces called out, including the North West Mounted Police, and spent his first day at his command post in the hotel in Qu'Appelle, chosen because it was the closest town to Winnipeg with a direct trail to Batoche. He sent and received telegrams in cipher, calling out members of the Canadian Militia—volunteers with

little or no training—and the Permanent Militia—the paid, full-time Canadian military force—from as far east as Québec City. Captain James Peters and his "A" Battery were among those called up.

What had started as a "peacekeeping mission" soon became the North West Campaign, and it rapidly assumed the nature of a "war" to suppress a "rebellion." In the words of Sir John A. Macdonald, the North West Campaign was officially considered to be little more than an exercise in riot control (Stanley, 386), but the statistics concerning the logistics and material of that campaign belie Macdonald's claim and reveal the true nature of how the Government of Canada intended to deal with this "riot":

> 5,456 soldiers in three columns, 586 horses, 8 cannon, 2 Gatling Guns, 6,000 Snider Enfield .50 calibre rifles, 1,000 Winchester repeating rifles, 2 field hospitals, 70,000 Gatling gun rounds, 1,500,050 rifle cartridges and 2,000 cannon shells for a total cost of $4,451,584.38. (Chambers, 104)

Captain Peters' photographs and dispatches from the battlefields also tell a different story from the one Macdonald's statements had attempted to create for public consumption. According to Foster, his photographs show the modern "empty" battlefield (Foster, 60–75)—empty in the sense that there are not two traditionally arrayed lines of soldiers moving toward each other across a landscape. Rather, this was a new kind of battlefield, of skirmish lines and unseen enemies taking cover in the trees and gullies of their home ground where, in some cases, they had built elaborate rifle pits. Here, the battle moved from the field to the bush. This marked the advent of modern "bush wars" or "guerrilla warfare," where indigenous people used their home-field advantage to confuse and disorient the invading force. On the other side, the invaders were an imperial power projecting their military might over thousands of miles, aided by the technology of steam power—steamships and steam trains were used to deploy and supply troops in the North West Campaign. The superior technology of the telegraph and rapid-fire, small-bore weaponry was also deployed against the "rebels"; the Great North Western Telegraph Company and the Dominion Government Telegraph Service were pressed into service and the Government of Canada supplemented their standard issue Snider Enfield rifles by purchasing one thousand Winchester repeating rifles that were issued to the best shots (Morton, 48).

But as Peters reports, there were problems: the railroad was not completed and the South Saskatchewan River, when it was not in flood, was not reliable for transportation by steamship.

The Métis were not completely unaware of the workings of the modern military. In fact they had received some military training under Captain Owen E. Hughes, a partner in the Hobart, Eden and Company post at Duck Lake. As justice of the peace, he referred to himself as "the sheriff," and organized the local Métis as the North West Mounted Rifles, a regiment within the Manitoba Military District. Gabriel Dumont was his lieutenant, but the troop was eventually dismissed as inefficient (Tolton, 136). It is not the case, therefore, that the Métis were at a strategic disadvantage because they did not know their enemy or its

tactics. Far more debilitating was their lack of weaponry and ammunition. Shotguns, muskets and a very few repeating rifles were arrayed by the Métis against the Canadian military's Winchesters, Snider Enfields and Martini-Henrys, well supplied with ammunition (not to mention the military's field cannons and Gatling guns).

While at first disparaging the fighting abilities of the Métis, Peters came to greatly admire their tactics and determination after suffering heavy losses at Fish Creek. He may have been trying to avoid embarrassment by claiming the enemy was the best fighting force ever faced, and that despite outnumbering them by ten to one, it took skill and determination to defeat them on their home field. But there is no question that his newfound respect for the Métis was genuine. He also began to change his attitude toward the Indians, eventually seeing them as brave and valiant warriors, and even expressing some sympathy for their situation and their cause:

> One old brave said that it would be cheaper for the Queen to give him pork than pay for all these soldiers. This was not a bad hit. (Peters)

Peters also became highly critical of Middleton's leadership, actually going so far as to refer to him as "The d____d old fool of a General" and "a helpless idiotic old imbecile" (Peters).

It is a bit of a wonder that Peters was able to rise through the ranks of the military, given his persistent and often strident criticism of the Militia on just about every count: from uniforms to recruiting, training and maintenance of arms and facilities. He had published his *"How Not to Do It": A Short Sermon on the Canadian Militia* in 1881 under the pseudonym "A Bluenose." His newspaper reportage during the War of 1885 was done under the pseudonym "Foggy." Yet these disguises would have been patently transparent to anyone determined to unmask such a ruthless critic of the Canadian military.

James Peters was born in St. John, New Brunswick, on September 11, 1853, and joined the militia in 1870, at seventeen, and the permanent force in 1872. After ten years of service, he was able to write his scathing indictment of the militia. The pamphlet was printed at the *Morning Chronicle* office in Québec, and its title, *"How Not to Do It,"* tells you just about all you need to know about its contents. In it, Peters attacked everything about the militia right down to the cut of the uniform pants. This critique continued in his correspondence from the front—he pulled no punches—yet he continued to advance through the ranks. It may well be that he was echoing a common feeling within the militia and, as his intended audience included the politicians who made the decisions concerning the military, he might have been speaking, if not exactly for, then at least indirectly to, his superiors, and therefore enjoyed their protection. The penultimate paragraph in his pamphlet demonstrates his style and sense of humour:

> As a segment of the British Empire, we are, of course, part of the British Lion, and though the part we represent may be situated near the tail, it is just that particularly sensitive portion of the noble beast on which intruders are cautioned not to tread. (Peters, *Militia*, 29)

A Photogrammatology of the Second Self

Paul Kane, the red-headed painter from Toronto, had passed what is now Battleford on the trail between Fort Carlton and Fort Edmonton in September 1846 (Benham, 29–30). When he found himself in trouble, forbidden to sketch the people he met, he explained that he was creating a "second self." The portraits he had sketched (and would often eventually paint) of their likenesses, he said, would see the Queen. He was not trapping a soul on paper, but rather making good medicine (Benham, 17) by allowing the subject's second self to visit the Queen. Captain James Peters' photographs, labelled "1885 N.W. Rebellion Views," represent not merely a history, but also a theory of photography. He, too, creates a "second self" for his subjects: Riel, Middleton, Moosimin, Poundmaker, Miserable Man, Mrs. Miserable Man, Beardy and Straubenzie to name a few, as well as those unnamed, in images such as "The Big Guns," "He Shot French," "Métis Dead," and "Métis Women." That photographic second self, then, can enter a dialogue with the viewer—the second self speaks to the viewer, the viewer speaks to the second self. His "Rebellion Views" is thus a record of that conversation—a conversation renewed each time the second selves of his subjects engage the gaze of a viewer outside the frame of space and time in which they were "captured."

When dry plate processes became commercially available through George Eastman and other manufacturers in 1882, anyone could purchase prepared glass plates, and with a little instruction and patience could load up to twelve of them into the newly invented "naturalist" cameras. Once the exposures were made, the camera could be easily unloaded in the dark, and the plates packed and delivered to a photographer or chemist for developing into prints. The 1880s were thus the beginning of the "instantaneous photograph" and, with it, the rise of amateur photography. No longer did one have to be a photography professor—anyone could now create photographs. Peters joined the new amateur photographic movement in 1884 when he was stationed at Québec City as captain of the "A" Battery in the Canadian Army Militia. He may well have been a member of Canada's first camera club, the Québec Amateur Photographers' Association, from 1884 to 1886, along with some professionals such as Jules-Ernest Livernois (Robertson, 170). As one of the 750 permanent members of the Canadian Militia, he was in a position where he could afford such a hobby.

He had acquired a Marion Academy twin-lens reflex camera in 1884 and began taking photographs in and around the Citadel at Québec City (Cooke and Robertson, 25). He could snap his hand-held camera almost anywhere, then reload by pulling a lever and turning the camera upside down. His first pictures were often of buildings or nature scenes, plus hunting trips, family excursions, tobogganing, snowshoeing and, of course, militia training manoeuvres. He seems to have mastered his instrument quickly, turning out clear, crisp prints, admirably composed. In taking photos for his own pleasure and that of his family and friends, he knew how to take instantaneous photographs under many circumstances, including severe cold and near blinding reflections off snow.

Taking his camera to the front as part of the North West Field Force did not cause him undue difficulty. There was only one thing he could not control as easily as he had done at home: the circumstances of his shots. As he came to see it very clearly when writing about

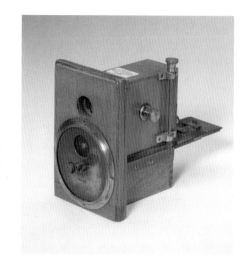

Marion & Co. Academy camera, ca. 1882.
George Eastman House, International Museum of
Photography and Film.

Sport with the Citadel Bear.
Library and Archives Canada E008300829.

his experiences after the fact, "circumstances alter photographs" (Peters). They determine not only the photographer's choice of subject, but also the photographer's ability to control the composition or narrative framing of the subject.

Peters' adoption of the nickname Foggy seems to be deliberate deprecation of his ability as a photographer during the War of 1885. He states that he often accidentally "fogged" his plates either in handling or in shooting. He mentions that many of his images from the front are underexposed and blurred, due in part to his taking most of them from the saddle, and some of them while under fire from the enemy. He is aware that he may be the first photographer to capture an image under these circumstances, but he mentions it only in passing and ironically—he is more worried about having his photographs fogged by a bullet. He was criticized by some of his peers within the army for taking too many photographs, but there is no record of any reprimand from his superiors—in fact he and his camera are mentioned favourably in official military telegraph dispatches from the front (quoted in Morton, 301).

It is significant that Peters repeatedly apologizes for the poor quality of his photographs, at one point claiming he has only one or two good shots from the expedition. The circumstances of battle limited him to long-range shots; the focus of his camera was almost always set for infinity. At these distances, it is not surprising that only four photographs are not bisected by a horizon line, a circumstance of the landscape that "altered" his photographs. Just as plainly, these four photographs are among the few that were clearly not taken from horseback. Three are in among the gun pits after Batoche—he would not have been able to ride among the trees and brush during the battles. The other is on the ferry across the North Saskatchewan. They are among the few relatively close-up images he was able to take. When Peters was less hurried, he was able to get closer to his human subjects. They are almost posed, but not primarily for the photographer; they are almost always of a criminal line-up or a negotiation between miscreants and the authorities. On horseback, Peters is stuck between the sky and the land, always with his eye and the camera lens focused on the horizon. The horizon becomes his chief reference, his framing circumstance.

Within Peters' "Rebellion Narrative," Louis Riel's iconography is complex. He is not a cowboy, but he is tied to the land—this land with no shade where he needs a hat when he is outside. He has fought for this land and its people twice; he has taken up arms, but never fired a shot himself. He is not a farmer, hunter, trapper, trader or government official. He has worked as a teacher. He has been elected to the Parliament of Canada three times—once actually signing the Parliamentary roll through subterfuge. The first by-election victory was in 1873, shortly after Sir George-Etienne Cartier's death, for whom Riel had originally given up the nomination in the 1872 election. Cartier, Macdonald's Québec lieutenant and a federal minister of defence, supported amnesty for Riel. Louis Riel won his seat again in the general election of January 1874. This time, he managed to attend Parliament in disguise, accompanied by friends, and signed the register. In short order he was stricken from the rolls, but managed to be re-elected *in absentia* in the subsequent by-election. The Province of Ontario had placed a $5,000 bounty on his head and he was threatened with arrest or assassination. The Conservative Party reneged on promises of amnesty under pressure from

the Loyal Order of Orange Lodges in Ontario, and Riel was exiled from Canada for five years in 1875. He stayed in the United States and eventually became an American citizen.

In his youth, Riel had studied for the clergy but did not graduate. He was president of one provisional government in Manitoba in 1870, spiritual advisor to another headquartered at Batoche in 1885. He wrote poems. He was anti-clerical. He allowed his men to hear each other's confessions. He had visions of a flag, a nation and victory. Mostly he prayed. Then he surrendered, but he never gave up. His image lives on and it has acquired new and powerful iterations as his second self continues to engage in an evolving public discourse with its viewers. Universities name their student housing after him. Statues of him now stand in public places of honour. There is a day of remembrance on the anniversary of his hanging. As a public presence, he is not dead—his image, his second self, lives. And it is the image taken by a Canadian Militia gunnery captain that "captures" Riel the prisoner, that completes his story by pointing both forward and backward, toward the past and the future at once. This photographic image is not a frozen moment, but rather a flexible referent, read, reread and misread as his story and history. But present in those readings is also always the story of the viewer and the photographer.

Why there are almost no photographs before the Battle of Fish Creek is unknown. It is possible that Captain Peters took some shots before the encounter at Fish Creek, but they were "fogged" by his fingers in the act of loading the camera. He may have been too busy with his military preparations. It is also possible that he may have waited for this very historic opportunity—the taking of photographs under fire. His later comments to the *Militia Gazette* indicate that he was aware that he might well be a battlefield photography pioneer. He may also have wanted his photographic ambitions to be less noticeable, so he waited until his superiors were otherwise engaged. It is also entirely possible that Peters took photographs prior to the battle, but decided not to include them when composing his various albums of the War of 1885, considering them to be "irrelevant" to the construction of his narrative.

His habit of loading the camera at night under field blankets and carrying his equipment in a leather carrying case slung over his shoulder suggests that he might have been able to take only a dozen shots a day. His lack of access to the makeshift "darkroom" of his tent might have prohibited reloading during the day; his military duties may also have prevented it. Although there are over eighty different photographs held between Library and Archives Canada, the Glenbow Museum and the Royal Military College, Peters claims variously that fifty to sixty-three of his battlefield photographs are "successful" images. Of course, any notion of success is subjective.

The Library and Archives Canada catalogue lists both Peters and his friend and fellow soldier from the Québec Citadel, Lieutenant William Imlah, as creators. Imlah is cited as one of the founding members of the Québec City Amateur Camera Club, which was established on February 8, 1887 (Robertson, 171). At least five photographs in the Peters family album are Imlah's. Four are clearly credited to him, while a fifth is most probably his; it is of the same subject in the same location under the same conditions as the other four.

A photographic image captures not only the second self of the subject, but also evokes the story of the viewer and the photographer. Photography is a narrative art, interrupted by

intervening explicit or implicit texts—there are always texts associated with photographs, the most obvious of these being titles and captions to monographs. These texts add to the narrative quality of the image (or images). If the photographer does not explicitly contextualize the image with text, as the word context itself states baldly, the image is loosened from ideology, becoming a free-floating signifier, virtually demanding the viewer to actively fill in the blanks. "Blanks" is in fact a good way to put it. The space between the marks—the unspoken, the empty mark, to borrow from textual studies—is where the reader or viewer finds the room to insert his or her view, opinion or imagination into the composition. Image does not, in and of itself, explain. The secondary act of the viewer's gaze is to search for context—an authority or authorization that may consist of the title, the creator's name, notes, archival cataloguing data and so forth—in other words the hidden or lost narrative so eloquently evoked by critic Pierre Mac Orlan: "Photography makes use of light to study shadow. It reveals the people of the shadow. It is a solar art at the service of night" (Wells).

That Peters won prizes for his photography indicates his level of skill and familiarity with the medium. He concedes that not all of his photographs from the War of 1885 received the proper time exposure, but given more pressing concerns at the time, he was not bothered by this. We also know that Jules-Ernest Livernois, the Québec City photographer, received a cartridge box full of glass plates from Peters in June 1885. When Peters made it home in July, the prints from these plates were already developed. From the more than eighty plates that Livernois received, Peters thought that at least fifty or more were good enough to publish (Peters). By the end of January 1886, Peters was advertising in the *Toronto Mail* "a certain number of albums each containing over 50 of his instantaneous photographs of the Northwest rebellion with a description of each picture" (Peters). The personal album that was passed down through Peters' family contains seventy-three; the presentation album he sent to Minister of Defence Adolphe Caron contains sixty-two. There is another album held at the Glenbow Museum with eighty photographs.

Peters destroyed his original glass plates upon his retirement from the military in 1906. His son Frederic Hatheway Peters donated the family album and another album of his father's photographs to the Public Archives of Canada in 1958. Unfortunately, due to the absence of original plates and the fact that Livernois printed his finished photographs the same size as the plates (rather than as enlargements), subsequent reproductions of those original prints are often less than charitable to the original "contact prints." While Peters himself makes no claims for his images other than "circumstances alter photographs," these two factors, the conditions of subsequent production and reproduction of these images from the original Livernois prints, have unfairly tarnished and diminished Peters' accomplishments as a photographer. "Unfortunately the bulk of Peters' work that survives is out of focus, underexposed or taken at too great a distance" (Beal, 12). But Cooke and Robertson come to Peters' defence: "In fact when viewed as the original prints, which Peters did not enlarge, they are not particularly fuzzy, but most researchers have worked from modern, often enlarged reproductions (Cooke and Robertson, 25). Having seen the originals, I would agree that the reproductions leave something to be desired.

Constructing the Narrative

The series of photographs in Peters' album, which includes "First of Fish Creek," "Limbering Up at Fish Creek," "Firing the First House at Fish Creek with 9-pounders," through "Fish Creek," "'A' Battery Supporting the Guns," to "Grenadiers Relieving the 90th, Fish Creek," "Front of Rebel Position," and "Driving the Rebels Back," was clearly taken on the field of battle, during the battle. There are scenes of smoking targets, a house, advancing troops and the repositioning of the cannon under Peters' command. These are hurried long distance shots that show, in part, how the soldiers stood out starkly against the prairie sky.

The day after that battle, Peters comes back to the field and begins a systematic cataloguing of events. He revisits the battlefield, photographs "Rear of Rebel Position," "Rear of Rebel Position Where 'A' Battery Attempted the Rush and Lost Heavily," "Rear of Rebel Position Where Ponies Were Killed," and also the immediate aftermath of the battle in "Sewing Up the Dead," "Some of Our Wounded," "The General and His Wounded Aides," and "Burying the Dead." The camp has been set up and he begins to chronicle its activities in "After Fish Creek," and a series of troop shots such as "Boulton's [Scouts]," "'C' Company and 'A' Battery," including a shot of officers formed up and outlined against the sky, satirically labelled "The Big Guns." He also turns his satirical eye to camp activities, titling one shot of a stolen cow being butchered, "The First Fresh Meat (Loot)," and another of a soldier barbering a comrade seated on a camp-stool, "Scalping."

In the days of waiting for Middleton to decide their next move, he turns his attention to the activities of the camp: "Shelter Trench Exercise," "Church Service," "Gun Pit" and a photograph of three scouts captured before the Battle of Fish Creek being interrogated outside their tent. One of the interrogators is wearing a Stetson and smoking a pipe, with his hands thrust deep in his trouser pockets. The scouts are under the guard of unseen soldiers. The subject of this image presages Peters' most famous photograph, that of the captured Louis Riel outside his prison tent. The scouts appear to be Indian, wearing blankets; elsewhere they are identified as such, although this identitfication is suspect. The Field Force does not know the status of the scouts, although they have most likely joined the Métis, if they are not already performing duties.

This group includes one photo that is a casual admission that the Canadian Army has been stymied. Titled "Our First Check, Fish Creek," the photograph shows a cannon parked ignominiously behind a woodpile as a horse and wagon rush off to do something more important.

There are three photographs that look outside the camp and the state of the army after being brought up short at Tourond's Coulee. A photograph labelled "Métis Women" shows five Métis women struggling down a hill carrying what one presumes to be all their worldly possessions. The photographer has adopted the position of the Métis and Indian fighters and is shooting upward at the women as they move toward him. Their side has won an astonishing victory, but some of these civilians end up in the next photograph, captioned "Refugee Camp." There are no people in this photograph of wooden boxes, blankets and quilts stacked outside of a tipi, but it seems clear that what the women were carrying has

ended up here. Perhaps they had left the house that Peters had fired on just before the battle was joined; perhaps it was their meat that the soldiers were butchering; and perhaps it was their ponies that were slaughtered by cannon fire.

Next, we come back to the army's reality; a caravan of wagons striking out over the prairie is titled "Wounded Leaving for Saskatoon." The final photograph is of "Lord Melgund and French Advancing to 'Gabriel's Crossing,'" the site of Dumont's homestead and ferry operation. He has abandoned it to the Fates. The scouts must be apprehensive—Dumont has just finished humiliating the armed might of the Canadian state with a poorly equipped but disciplined army of plains fighters eager to finish the job begun at Tourond's Coulee. They may be no match in terms of numbers and armaments, but they can fight and they know it. If only Riel would let them. Once the Métis had taken up arms, Riel and Dumont disagreed on tactics: Dumont felt that the Métis must take the battle to the Canadian Army in a series of guerrilla raids, whereas Riel held out for a defensive strategy still hoping to negotiate a political solution.

There is one photograph labelled "Old Howrie" (the proper spelling is Hourie). Peter Hourie was one of Middleton's Métis interpreters. His son Tom was a teamster and a scout who eventually captured Louis Riel after the Battle of Batoche, although "capture" may not be the right word, as we will soon see. Assuming it is Hourie who is closest to the camera, he wears a fedora hat and appears to be driving the lead wagon (although there may be more in front of him). We cannot see his team, but a team of mules pulls the wagon behind him. Peters states that the noise of the mules and oxen disturbed the sleep of the men in the Fish Creek camp after the battle. Storm clouds are gathering in the sky behind Hourie and what appear to be his military companions. The wagon behind Hourie's is set up in entirely the same way—the guard is wearing a military-style fur cap, while the drivers both wear brimmed fedoras or Stetsons. Stetson was a brand name favoured on the Prairies, available at most HBC and independent trading posts, such as Stobart and Eden at Duck Lake. Both drivers are wearing heavy coats, likely buffalo robes, while the guards are wearing uniform jackets. No guns are evident, but we know that transport teams ran in convoys under armed guard. These wagons, however, do not look like they were intended to cart hay or feed, but something smaller and heavier. Hay would likely have been transported in two-wheel carts, like the ones in the photograph of the Sioux scouts captured before Fish Creek. This reliance on overland transport accounts for many of the early delays of the expedition. Middleton and his army had also waited for the arrival of the steamer *Northcote*, which was supplied by rail and wagon at Saskatchewan Landing, twenty miles north of the rail stop at Swift Current. The steamer was slow because the river had not reached full flood; it kept getting hung up on sandbars and continually had to "grasshopper" its way off.

The thunderclouds in the Hourie photograph are echoed in the photograph of the *Northcote* when it finally arrives at Fish Creek. Captioned "*Northcote* Before Batoche," it shows the steamer tied to the riverbank with a ramp leading onshore and men handling freight. The two smokestacks tower over the landscape and the slightly smaller spars that make up the "grasshopper legs" angle out over the bow. The *Northcote* was able to deliver twenty-two tons of freight, including the Gatling gun and "Mad" Captain Howard—"friend of the

gun"—to crank the handle (Howard, 451). Among the freight was more ammunition; among the passengers were a few reinforcements. Middleton saw the arrival of the steamer as an opportunity; he knew where he could get thick planks to protect its cabin and open decks from gunfire. Gabriel Dumont's stables on the river at Gabriel's Crossing between Fish Creek and Batoche were deserted and were soon dismantled to afford the *Northcote* its much-needed protection. Dumont's prized slate billiard table was also used as a shield. It ended up in the hands of Captain Bledsoe, who became the warden of Stony Mountain prison where Big Bear, Poundmaker and the Métis prisoners were held.

Middleton's planned surprise attack with his jury-rigged "battleship" did not fool the Métis fighters. They were ready for this distraction with a simple plan to disable the *Northcote* and take it right out of the fight—they planned to lower the ferry cable at Batoche in order to slice off both the cabin and the smokestacks.

The army was massing for an attack on the Métis capital of Batoche. The photographer seems almost jubilant as he announces the "First Sight of Batoche," another picture divided in half by the horizon. A soldier is at the extreme left, bottom corner looking toward the target. The next photograph, "Opening the Ball at Batoche," shows a split rail fence marching from the lower right to the middle left and the horizon, where it is obscured by smoke. This image has often been used to illustrate the Métis tactic of starting prairie fires to shield themselves from the soldiers and to disorient and drive back aggressors (Morton, 83; Charlebois, 192). However Peters' caption clearly indicates that the burning building had been hit by the first cannon balls fired by Peters, and by the nine-pounders of his "A" Battery. Given that it is a pasture fence, the guns are evidently close to the edge of the village. The targets are now visible and not moving. Unfortunately Peters only took ten shots during the days of the Battle of Batoche—some of which were back in the Zareba, where Middleton had ordered trenches dug and boxes stacked just beyond the church.

In the next image, General Middleton's second self is talking to those of the priests at Batoche, in front of their small, unpainted home. The photograph clearly indicates that the camera is being held above the subjects from a distance. Peters is on horseback. Middleton has dismounted; his adjutant is holding the reins of his horse; and several soldiers on foot are discreetly guarding the general. There is a wagon and a two-horse team standing nearby, ready to move off. There are leafless trees in the background, and the immediate foreground is bare. One of the priests, Father Fourmand, has said that Middleton was nervous and on edge, looking around constantly, particularly at the bushes a short distance to the right and left (quoted in Hildebrandt, 45). We also know from Father Fourmond that there was good reason for Middleton to be nervous; seconds after the picture was taken, in the middle of the conversation, shots rang out from the bushes. The soldiers had to mount up quickly and beat a hasty retreat, knowing that the Métis still had the advantage of cover and at least some ammunition.

"Shelling Batoche, the Last Shot Before the Attack on the Guns" shows a puff of smoke rising from the cannon and a larger, fuller cloud of smoke rushing out of the barrel; there are also horses shying and a small black and white dog turning back at the sound of the cannon. The dog is caught in mid-stride, moving forward but twisting to look back.

The Battle of Batoche raged over four days, with the soldiers moving forward and retreating, unable to keep the ground they had won. Peters was kept busy with his cannon and had little time for pictures, but when the fighting ceased on the final day, he took a series of three photographs that have no horizon. The first is "How They Left Their Pits," a close-up of an abandoned rifle pit from the rear, with trees circled from the left around the front. The Métis had left their blankets here, and it is clear the pits were spacious enough that a fighter could have encamped for days. The white cloth against the ground is shocking, recalling the cloth body bags into which the army's dead were sewn.

The next photograph shows three dead Métis stretched out on the ground where they fell. Titled "Shot Dead," it is a reminder of earlier battlefield photography in which the only enemy that could be photographed on the battlefield was a dead enemy. Although these kinds of photographs were sometimes posed, there is no sense of that in this picture.

Labelled "He Shot Captain French," an elderly man is stretched out awkwardly on his back with the empty right arm of his black coat extending at an odd angle over his head. His pants have ridden up his leg and waist, while his jacket has been nearly pulled off. His arm has been bent out of shape and remains over his head, as though he had reached up to protect himself from a bayonet. His head has lolled to the side as if his neck is broken. The caption leaves him nameless, but we know him variously as Donald, Daniel or Alexander Ross. He is an old man who in the end wanted only that his children and grandchildren be brought to him "before he passed away to the unknown world" (Riel quoted in Charlebois, 199).

The pictures after Batoche are relative close-ups. The bodies occupy most of the image area; there is no horizon and almost no context—they could be anywhere. Here it is just bodies and the land beneath them. There is nowhere left to go, no hills to retreat behind, no coulees to hide in—just the bodies of enemy combatants stretched out on the ground, alone, with no one to comfort them. Disarmed, disclosed and no longer able to stand, the human body after war is not a pleasant sight. There is no longer a present human "subject" for its absent "second self."

The *Northcote* had drifted four or five miles downstream to Gardupuis Crossing, where the new camp was set up after Batoche had been secured and as many arrests as possible had been made. Peters photographed the partially disabled but still barricaded *Northcote*. The Métis counter-attack had not worked out as planned. The vessel's fortifications were still in place; only its smokestacks had been reduced. There are two photographs of the camp: the first shows the camp ranging up a gentle incline; the second records the breaking of the camp. Then there is another titled "Navigating the St. Lawrence" that shows men on horse-back wading through the river. "St. Lawrence" may be a misspelling or a play on "St. Laurent," which is nearby.

By far the most important shot at this location is the first picture of Riel as a prisoner of war. In "Louis Riel, a Prisoner," Riel is shown standing outside a canvas wall tent with a hand in his pocket. There is a line of guards between him and the river. There is a leafless tree between his guards and the river. The horizon bisects the photograph; then we see the sky. Riel seems to be speaking to someone out of camera range. He is a big man, bulkier than the guards. He looks like a cowboy ready to jump on his horse and light out for the territories,

but he has been caught, or has turned himself in. He is wearing a grey Stetson hat with the brim turned up on the sides. To wear a hat like this, in this position, is to be free, to be free to think that you will need the protection of a hat. It is a small gesture of defiance—he is defeated, imprisoned, under guard, but yet he still may need a hat of this order to protect him from the sun, the wind, the rain, of this land. He is still human, civilized, he can observe a mannerism that will soon be unnecessary, in prison, in court and in death. His hat, when he removes it for the final time, is his death. His shelter as a free man will be gone. His home will no longer be his own. His exile will be complete, spectral but complete—exiled to this second self.

The Métis leader has his left hand in his pocket. He has turned away from the land; it is what he holds in his right hand now, a bible, which is his only hope for the salvation he so desperately seeks. The land, empty for the moment except for soldiers, has turned its back, the prisoner who was a refugee until his surrender. Refugees are almost always invisible. We traditionally get only fleeting glimpses of them, until the land has been cleared and they are contained. Riel has lost and is lost, prayer is his only hope; the inexorable march of civilization—there is a certain inevitability that the marching will be done by soldiers—has taken him up. He wears a white armband tied above his left elbow; don't kill me. Riel's second self cannot be killed.

The picture has cut off his ankles. He has nothing to stand on, no ground at his feet, he stands alone, under the grey prairie sky, alone with his guards and the cameraman, who catches him unaware. He does not look at his captor, nor does he deliberately ignore him, he simply does not notice; he has more on his mind right then and there. He is contemplating his own image: the image of surrender, a bible in one hand, a white cloth indicating that he is not armed on the other arm, and a cowboy hat on his head.

Meanwhile, Middleton and his men have work to do. First they must liberate Prince Albert. The camp at Prince Albert is far more substantial than the prairie camps before and after Batoche. The general is back, fully in charge, ordering the men to erect sentry boxes and mess tents (Morton, 129). Peters visits a Cree camp with his friend Lieutenant William Imlah and snaps a picture of Moosimin, a Cree chief loyal to the crown. At some point, Peters must have handed the camera to Imlah, who took five photographs. One picture shows three warriors squatting on a cowhide; one warrior has a long rifle across his lap. There is a fair-haired, white man standing behind them, leaning on his rifle. There seems to be mutual good feelings between the photographer and the men in the photograph—they do not appear to be prisoners. They are composed and presentable, dressed for a photograph, not for war. This image is titled "Crees at Prince Albert." Imlah also took three camp photos (see Appendix B).

The troops move upriver to Fort Carlton, recently burned to the ground by the NWMP, who had left when they realized they could not hold it against the Métis. Peters took two pictures at this time. The first is of the cable ferry, which used the river's current to cross from one shore to the other; the second, taken onboard the flat-bottomed scow during a crossing, shows it jammed with horses, wagons and men. The men are on a mission. They are heading upriver to hunt down the "nitchies," as Private Will E. Young of the Field Force

referred to Big Bear, Poundmaker and Beardy (Young). His invoking of this derogatory term reflects the widely held colonial opinion that Indians were "nits"—a lesser life-form.

There are no more opportunities for Peters to take photographs under fire. From this point on, his pictures show prisoners who have surrendered, and the futility of the chase. In "On the Big Bear Trail," a stream of men and horses leads along the river, under a cloudless sky. The perspective of the photograph is again slightly elevated because Peters himself is on horseback.

They encounter a small band of Chipewyans, distant relatives who have broken away from Big Bear when they realize they can run no farther. Peters moves in from his usual distance and elevation. In "Chipweyan Camp," the first image Peters takes, the horizon line is in the lower half of the frame. This photograph shows seven tipis and a round structure that looks like a sweat lodge. There is a small group of people at the entrance to the round lodge, perhaps waiting their turn to enter. To the right, a dog is seated but alert. The second image of this series has the same title, but Peters seems to have circled around to the back. The round structure appears again in this picture, plus another structure to the right—a small wall tent with an alert dog picketed in front, facing the camera. To the left is a woman leaving a tent. Another dog is watching, perhaps hoping for a scrap. The tipis look considerably less than imposing—in fact they look ramshackle, improvised, patched together. The final photograph of this section, "Pow Wow with Chippeweyans," shows the backs of six seated Indians with long black hair. The Indians face three white men in various stages of repose in front of a wall tent with its front flaps drawn back. On the left, an Indian or Métis in a dark Stetson and jacket, who is closest to the three whites, has turned his attention to them. The scout in a light rolled-brim Stetson is kneeling almost in front of, but across from, a man in a military cap who is reclining with papers. The third man on the far right, dressed in dark clothes and a fur hat leans in. This may be an interpreter translating for the army in this "pow wow."

In the next section, the army is back on the trail—the Beardy trail—except it's Beardy who finds them, and gives himself up. Then a series of three shots: "Beardy Trail Pow Wow," "Pow Wow with Beardy," and "Beardy and His Chiefs." Relations have changed. In all three photographs, the white men are standing and the Indians—all chiefs—are sitting, waiting. The first two images are basically the same. The first, from a distance, includes fourteen men: soldiers, Middleton (recognizable by his distinctive profile), a priest, a reporter with a pad and pencil, and two Indians, seated. One is Chief Beardy in a white headdress; the other is dressed in black and almost indistinguishable. In the second photograph, Peters has moved closer and Middleton is cut off on the left. There is a priest in his cassock, a man in a cutaway coat, his right hand grasping his lapel, a series of militiamen and, third or fourth from the right, a reporter. It is George Ham of the *Toronto Mail* in profile, looking down at his notes. The embedded reporter is speaking to a soldier who has turned to face him. Two or three more soldiers complete the line. The angle is better. Peters is on foot and we can now see the other chief next to Beardy is wearing a top hat. They sit patiently.

In the next picture we see Beardy and his five chiefs sitting cross-legged beside the man in the cutaway topcoat, now with both hands in his pant pockets. He is staring straight at the camera; a watch fob stretches over his waistcoat. The time to end this "adventure" has arrived.

The last sequences of photographs in this section are of the same nature, except the background includes constructed space and hints at the imprisonment that is in the future for many of the Indians who are surrendering. The first of these images is of "Miserable Man Surrendering at Battleford." Six unarmed Indians in blankets stand facing something or someone off camera left. The camera is oblique to their bodies—Indians two and three have turned their heads to the camera and are moving their right hands to their faces. It is a classic "perp walk," a police "lineup," viewed not only by witnesses but also by the camera. The Indians led by Miserable Man have been "caught" on camera.

The next photograph, titled "Mrs. Miserable Man," is one of the few that position women as central in any way. She stands dead centre beside her grazing horse in an elaborate buckskin top and long skirt. Her black hair hangs down in two braids on either side of her face. She is not directly facing the camera, but is casting a sidelong glance at the soldier with the box in his hand. She sees it sparkle once and the man walks away. There is a soldier seated on top of a corral fence at least eight to ten feet high. There are horizontal stringers from post to post with crooked poles running vertically, spaced every six inches or so. You can't distinguish the posts from the uprights. The soldier is wearing a helmet, straddling the top rail. The horizon line runs right beneath his feet. You can see it through the breaks in the fence. The fence is to keep livestock in and the horizon out. The horizon is just a broken line. Mrs. Miserable Man does not look happy.

The next three pictures repeat some of the tropes of the previous series, only with Poundmaker as the named subject. First there is "Poundmaker and Chiefs," in front of the same fence but in a different location, possibly on the other side. There is no livestock, but two soldiers armed with rifles and at attention are lined up between the Indians and the fence. Of the seven chiefs, two to the right are in white blanket coats. One has his arms crossed. Next is Poundmaker, with his long braids hanging to his waist and his painted face staring impassively, directly at the camera. Poundmaker is at the centre of the image; there is another person whose body is cut off by the left margin, and a leg is visible. Poundmaker and the four to his right are dressed in darker blanket coats or are in shadow. All seem to be waiting patiently.

Poundmaker had many of his "second selves" made and he understood that his soul would not be trapped in the box the soldier was holding. Like the "second self" who had seen the Queen, this "second self" would be there to tell all of their children that in time the land would once again be theirs. The white man would be done with it and abandon it like the Great Mother has abandoned her children. He does not know when this will come to pass. But it will, he knows it will, and this photograph and many more of Poundmaker and the others, many of their "second selves," will survive. Their "second selves" will see the land come back to the Indians. It cannot be bought and sold forever without wearing out those who do the buying and selling.

The last two photographs in this sequence are labelled "Straubenzie and Poundmaker," and "Poundmaker, a Cree Chief," respectively. Straubenzie is "Old Straw," the colonel whom Peters credits with deliberately misinterpreting Middleton's order and leading the final charge at Batoche, moving forward until he experienced resistance (Peters). He has never stopped since, and now he is pictured accepting Poundmaker's surrender. The last two pictures are basically of the same event, photographed from different angles. In the first of these, Straw—wearing a helmet, pictured beside a soldier, second from the left—is talking to an interpreter, with Poundmaker facing the two of them. The image includes a soldier with his back to the camera. There is a wagon hitching post and possibly flagpoles just in front of a different section of the same fence. The next picture, "Poundmaker, a Cree Chief," is taken from a different angle. Straw is flush left, talking animatedly to the interpreter; Poundmaker is dead centre, listening intently, while two soldiers stand stiffly to the right, one at attention, one with his hands on his hips. Neither are more than two steps away from Poundmaker. The subject of the meeting is food; he has given himself up so the soldiers will stop chasing his people and the agents will give them something to eat when they return to their reserve. He knows he will not be going home for a while, if ever. He knows he is going to the white man's big house with iron doors. Why can he not stay in the white man's big house right behind him, closer to his people? It has many rooms on two floors like the big house, only it's not so far way. If he could stay there—and he would—his people could see him and he could talk to them through the open window on the second storey. He would tell them this picture taken today would last longer than all of the men in it. What he said at his trial was: "I would rather prefer to be hung than to be in that place" (Parliamentary documents quoted in Howard, 499).

Poundmaker's "second self" will see the land and the horizon and the sky again some-day through neither fences nor bars—only the land and the sky and the crack between, the horizon. What more could he ask in this time, in this place, in this picture?

But the war is not over yet. The mission is not yet complete, the compositional narrative is unfinished. Big Bear is still at large. "First Ford, Loon Lake, Scene of Steele's Fight," and two more photos titled "Second Ford, Loon Lake," and culminating in "Second Ford, Loon Lake, Where Gen. Middleton Turned Back," all show the same thing—an army in trouble, literally thrashing around in shallow water unable to go on. Middleton turns back. He does not really know where he is going, but now he can afford to wait for the Indians to give themselves up. Days later Big Bear and his exhausted band turn themselves in to the only Mounties not actually looking for them, at Fort Carlton, a hundred miles back the way the army had come. They are only a day away from Batoche. Big Bear wants rations for his people. Beef, flour, sugar and tea, for these he will turn himself in, with his youngest son, Little Bear, at his side.

Peters has run out of plates. He packs those he has not fogged into a cartridge box and ships them off to Québec City to be developed and printed.

Fatal Offsprings

Jean Baudrillard begins his *Photography, or the Writing of Light* with:

> The miracle of photography, of its so-called objective image, is that it reveals a radically non-objective world. It is a paradox that the lack of objectivity of the world is disclosed by the photographic lens (objectif). (Baudrillard, 1)

and ends it with:

> Reality found a way to mutate into an image. This puts into question our simplistic explanations about the birth of technology and the advent of the modern world. It is perhaps not technologies and media which have caused our now famous disappearance of reality. On the contrary, it is probable that all our technologies (fatal offsprings that they are) arise from the gradual extinction of reality. (Baudrillard, 7)

Peters' war photography evokes the technological triumphs of the age: steam-powered ship and rail transportation; armaments, the cannon and the Gatling gun; communications, the telegraph and newspapers; and finally photography itself. In the case of Captain James Peters, that photography may seem as simple as a man on horseback replicating his role as a gunnery Captain: viewing the subject, aiming and shooting. But there are also the technology of the lens, the shutter, the coated plate and the developing chemicals to consider, and the existence and technology of paper, as well as the printing press, if the image "shot" in this particular circumstance is to be disseminated, thereby altering the public realm or history. Peters' quotation "circumstances alter photographs" subtly anticipates Baudrillard, while his pseudonym "Foggy" intentionally, ironically and playfully undercuts the constructed "reality" of his photographic work.

If, as I have suggested, photography gives the subject a second self, it is this second self that discloses our reality. But that reality is always a fiction, as we have seen—imagined, made up on the spot to explain what we are seeing in the image in front of us, but also what we imagine the image sees in us. The second self speaks its reality to us. We speak back. We are neither objective, nor real, but rather images of a mutable objectivity and reality. The image can see us and speak to us, as we can see and speak to it, across time and space.

I have included my own textual interventions in this introduction, but deliberately kept them separate from the images and Peters' related reports in order to allow the images to speak to the viewer and the viewer to speak back. Peters did what he could with his images: his "fatal offsprings" were preserved, catalogued and distributed. Now, his "Rebellion Views" has been recollected here in order to set the record straight.

The evidence is clear, Foggy might say.

An Historical Footnote

The noted Canadian novelist, essayist and public intellectual John Ralston Saul suggests in his latest book *A Fair Country: Telling Truths about Canada* (Penguin, 2008)

> that Canada is a Métis Nation, heavily influenced and shaped by aboriginal ideas: egalitarianism, a proper balance between individual and group, and a penchant for negotiation over violence are all aboriginal values that Canada absorbed. (johnralstonsaul.com)

Saul argues, citing Psalm 72, that the biblical values of "peace, welfare and good government" became the Canadian values of "peace, order and good government" (Saul, 158). Unfortunately, nowhere in Psalm 72 do the words "welfare", "order" or "good government," appear. In fact, only the official motto of the country can be found verbatim in line 8 of Psalm 72: "May he have dominion from sea to sea," evoking as it does the Dominion of Canada created by the British North America Act in 1867.

The fathers and mothers of Métissage were in many ways colonizers who got it right; join the culture where you move, learn the language, join the tribe, live the life, become one with them. Yet in Canada, the Métis were sacrificed to the corporate needs of the HBC, the Church in its various iterations and the CPR, by the government of the day and its "National Policy" of imperial dominion. The HBC needed contractors they could lay off in the winter not employees they had to feed off-season; the Church needed souls at any cost, including forced conversion of children in residential schools; the CPR needed land they could sell to colonizers to first finance its construction and early operation, then to continue to exploit as captive consumers. All of the above are state-sponsored acts of great violence done to weakened nations, to use the contemporary terminology.

Saul's assertion that Canada prefers negotiation to violence does not bear scrutiny. Any argument suggesting that Canada is a "Métis country" should account for the treatment of the Métis throughout Canadian history, otherwise the whole thesis is little more than a rhetorical device: a very politically attractive piece of hyperbole perhaps, but nonetheless a blatant exercise of self-congratulatory, co-optive revisionist history—all the more offensive because it retroactively appropriates the values of a people defeated by the Canadian government in a civil war in 1885, whose leader was subsequently hanged for high treason.

An alternate reading of Saul's thesis could be that the prehistory of what was to become the Canadian nation consisted of domination tempered by negotiation because there was no demographic or technological choice. However, by the 1880s, Canada's indigenous peoples no longer outnumbered the colonizers and the building of the railroad allowed the new nation to project its military might in sufficient strength to actually defeat its newly-created "enemies" on the battlefield. The difference between the "First Riel Rebellion" of 1869–70 and the "Second Riel Rebellion" of 1885 is precisely that. Negotiation no longer served the aims of the government in Ottawa. In the first "rebellion," the brand-new nation of Canada had little choice but to negotiate an end to the Métis resistance to its self-declared manifest destiny of creating itself as a "Dominion from Sea to Sea," whereas in the second "rebellion,"

despite much pleading by the Métis and many other parties including white settlers and Indians of the great plains, no negotiations were ever even considered by Canada.

The new nation—less than eighteen years old—chose to go to war rather than negotiate with the people whose land it had "purchased" without their consent when Canada bought out the HBC land grant from the Crown of England. In this process, basic human rights, pre-existing treaty rights and legal contracts were abrogated time and again until the aboriginals and Métis were starving, literally begging to come to the table to speak. Even the white settlers noticed and were moved to make representations to Canada on behalf of their neighbours. And, most telling of all, even the soldiers sent to put down the "riot" couldn't help but remark on Canada's blatant mistreatment of "our" Indians.

In fairness, Saul does point to 1885, when the nation declared war on its own people, as a turning point in Canada's treatment of Indians and Métis people, and a very good theoretical and retroactive case can be made that Canada could and perhaps should have become a "Métis Nation." The reports and images from this "civil war" by Captain James Peters prove unequivocally, however, that while Canada may dream of itself as a "Métis Nation," simply saying so does not make it so.

Works Cited

Baudrillard, Jean. "*Photography, or The Writing of Light*." Translated by Francois Debrix. *Ctheory* 2000.

Beal, Bob and Rod Macleod. *Prairie Fire: The 1885 North-West Rebellion*. Edmonton: Hurtig Publishers, 1984.

Benham, Mary Lile. *Paul Kane*. Don Mills: Fitzhenry & Whiteside, 1977.

Chambers, Ernest J. *The Canadian Militia: A History of the Origin and Development of the Force*. Montréal: L.M. Fresco, 1907.

Cooke, Owen and Peter Robertson. "James Peters, Military Photography and the Northwest Campaign, 1885." Canadian Military History 9(1): 23–29 (Winter 2000).

Flanagan, Thomas. *Louis "David" Riel: Prophet of the New World*. Toronto: University of Toronto Press, 1979.

Foster, J.A. *Muskets to Missiles: A Pictorial History of Canada's Ground Forces*. Toronto: Methuen, 1987.

Hildebrandt, Walter. *The Battle of Batoche: British Small Warfare and the Entrenched Métis*. Ottawa: Environment Canada—Parks, 1986.

Howard, Joseph. *Strange Empire: Louis Riel and the Métis People*. Toronto: James & Lewis Samuel, 1974.

Kane, Paul. *Paul Kane's Frontier*. Austin: University of Texas Press, 1971.

Koltun, Lilly, ed. *Private Realms of Light: Amateur Photography in Canada/1839–1940*. Toronto: Fitzhenry & Whiteside, 1984.

McLean, Don. *1885, Metis Rebellion or Government Conspiracy?* Winnipeg: Pemmican Publications Inc., 1985.

Middleton, General Sir Fred. *Suppression of the Rebellion in the North West Territories of Canada*. Toronto: University of Toronto Press, 1948.

Morton, Desmond. *The Last War Drum*. Toronto: A.M. Hakkert Ltd., 1972.

Peters, James. *"How Not to Do It": A Short Sermon on the Canadian Militia*. Quebec City: *The Morning Chronicle*, 1881.

___. Letters and Correspondence, this volume.

Robertson, Peter. "The New Amateur." In *Private Realms of Light: Amateur Photography in Canada/1839–1940*, edited by Lilly Koltun. Toronto: Fitzhenry & Whiteside, 1984.

Saul, John Ralston. *A Fair Country: Telling Truths About Canada*. Toronto: Penguin, 2008.

Stanley, G.F.G. *The Birth of Western Canada: A History of the Riel Rebellions*. London: Longmans, Green and Co., 1936.

Tolton, Gordon E. *Prairie Warships: River Navigation in the Northwest Rebellion*. Vancouver: Heritage House, 2007.

Wiebe, Rudy and Bob Beal, eds. *War in the West: Voices of the 1885 Rebellion*. Toronto: McClelland and Stewart, 1985.

Young, Will E. *With the Midland Battalion During the North West Rebellion of 1885*. Vernon: Edinburgh Square Heritage & Cultural Centre, 2001.

Bibliography

Barthes, Roland. *Camera Lucida: Reflections on Photography*. Translated by Richard Howard. New York: Hill and Wang, 1982.

Benjamin, Walter. "The Work of Art in the Age of Mechanical Reproduction," translated by Harry Zohn, in *Walter Benjamin, Illuminations*, edited by Hannah Arendt. New York: Schocken, 1968.

Bourdieu, Pierre. *Photography: A Middle-brow Art*. Stanford: Stanford University Press, 1990.

Bowsfield, Hartwell. *Louis Riel: Rebel of the Western Frontier or Victim of Politics and Prejudice?* Toronto: Copp Clark, 1969.

Carol, Lindon. *Gatling Guns at the North West Rebellion*. Edmonton: Shorthorn Press, 1999.

Dumont, Gabriel. *Gabriel Dumont Speaks*, rev. ed. Translated by Michael Barnholden. Vancouver: Talonbooks, 2009.

Freund, Gisele. *Photography and Society*. Boston: David R Godine, 1980.

Kahmen, Volker. *Art History of Photography*. New York: Viking Press. 1973.

Kracauer, Siegfried. *The Mass Ornament: Weimar Essays*. Translated by Thomas Y. Levin. Cambridge: Harvard University Press, 1995.

Langford, Martha. *Suspended Conversations*. Montréal: McGill-Queen's University Press, 2001.

Miller, J.R. *Skyscrapers Hide the Heavens: A History of Indian-White Relations in Canada*. Toronto: University of Toronto Press, 1989.

Morton, Desmond, ed. *The Queen v Louis Riel: Canada's Greatest State Trial*. Toronto: University of Toronto Press, 1974.

Mulvaney, C.P. *The History of the North-West Rebellion of 1885*. Toronto: A.H. Hovey & Company, 1885.

Macleod, R.C., ed. *Reminiscences of a Bungle by One of the Bunglers and Two Other Northwest Rebellion Diaries*. Edmonton: University of Alberta Press, 1983.

Payment, Diane. *Les gens libre Otipemisiwak, Batoche, Saskatchewan, 1870–1930*. Ottawa: Government of Canada, 1990.

Robertson, Peter. *Relentless Verity: Canadian Military Photographers Since 1885*. Toronto: University of Toronto Press, 1973.

Siggins, Maggie. *Riel: A Life of Revolution*. Toronto: Harper Collins, 1994.

Sontag, Susan. *On Photography*. New York: Picador USA, 2001.

Stonechild, Blair and Bill Waiser. *Loyal till Death: Indians and the North-West Rebellion*. Calgary: Fifth House Publishers, 1997.

Tagg, John. *Grounds of Dispute: Art History, Cultural Politics and the Discursive Field*. Minneapolis: University of Minnesota Press, 1992.

Tagg, John. *The Burden of Representation: Essays on Photographies and Histories*. London: Macmillan Education, 1988.

Trachtenberg, Alan. *Reading American Photographs: Images as History, Mathew Brady to Walker Evans*. New York: Hill and Wang, 1990.

Waiser, Bill and Blair Stonechild. *Loyal till Death: Indians and the North-West Rebellion*. Don Mills: Fifth House Ltd., 1997.

Wells, Liz. *The Photography Reader*. New York: Routledge, 2002.

Woodcock, George. *Gabriel Dumont: The Métis Chief and his Lost World*. Edmonton: Hurtig Publishers, 1975.

CIRCUMSTANCES ALTER PHOTOGRAPHS

The following texts are, in the main, Captain Peters' dispatches from the front, fleshed out with various letters and clippings related to the war and his photography. I have attempted to keep the spelling and language as close to the original as possible, including variant spellings. I have chosen to format the letters full page, while running the newspaper dispatches in columns to evoke the originals.

THE CANADIAN MILITIA GAZETTE 1(32): 252
Tuesday, December 15, 1885

CAPT. PETERS' NARRATIVE.—"The photographs, I fear, will not agree with the ordinary idea of what a battle really should look like after those striking and startling productions that appear in our illustrated journals. I am sorry for this, but the fault is not mine. I selected the most important incidents and positions during the actions of Fish Creek and Batoche, and if they are not equal to a first-rate carnage produced from the office of the above-mentioned papers, why I must throw the entire blame on the 'Marion Academy' camera, the maker of which should apologize to the public, and I have not the slightest doubt but that he will when he views the composed and apparently indifferent appearance of the Canadian Soldiers, pitted against the best skirmishers in the world, the Half-breeds and Indians of the North-west Territories. I carried the instrument slung on my back most of the time, and took many of the views from the saddle, for I had, in addition to the camera, a battery of artillery to look after; and the fact that 20 per cent of my men were killed and wounded in the two engagements will be sufficient guarantee as to the indisputable fact of the plates being exposed actually in the fighting line. On more than one occasion the plates stood a most promising chance of being fogged by a bullet hole, but luckily such a mishap did not occur. It is quite wonderful what the instrument did stand, for, after the victory at Batoche and general smashing up of the rebels by Sir F. Middleton I clung to the camera in the celebrated chase after Big Bear, the Cree chief, who took us nearly 100 miles north of Fort Pitt right into the woods in the latitude of Hudson's Bay. During this part of the campaign, which was entirely with mounted men, we were forced to abandon our tents, and only allowed half rations, in blankets, which proved another inconvenience to photography, as the regimental blanket was the only changing tent to be obtained. My plan of pitching it was to lie on my back on the prairie after dark—in fact, I often combined the operation with the details of preparing for bed, pulling the covering up—or, more properly speaking, 'getting under the clothes,' when, by a delicate sense of touch, I generally managed to get most of my plates into the box, with a fair proportion having the film side to the front. Unfortunately, many were destroyed from the fingering necessary to make sure of the correct side to be placed towards the shutter. Necessarily I had many failures, for out of ten dozen shots only 63 good pictures were obtained, but these proved so interesting that all my labours were amply rewarded. One valuable batch was lost to me for ever, from the fact that as soon as the changing was completed I fell fast asleep through fatigue; had I slumbered quietly all would have doubtless been well; but, unhappily, a bad dream upset all my calculations, and next morning my valuable plates were all kicked out in the long grass and ruined. After this I never slept with the camera. The total distance travelled by the instrument was about 5,800 miles, about half of which was over the prairie with the troops, when most of the time it kept company with an energetic artillery trumpeter. I am convinced of one fact, and that is that no tripod instrument would for a moment survive such a trip; nor would it do for taking pictures in action, for I found that the rebel marksmen of the far West did not give an amateur photographer much time with his 'quickest shutter,' and I tremble to think of the

fate of the artist who would attempt to erect his tripod where the enemy possessed such a large number of 'spotters,' as they call the expert riflemen of the plains. Some of them were vain enough to allow me an occasional instantaneous snap; but their desire never went so far as to allow the planting of the three sticks or the focussing with a black cloth. I marked the sighting or focus on the side for two distances, one at twelve paces (which it is needless to state was only for dead men). For the live rebels, I generally, for fear of fogging, took them from a distance, as far and as quickly as possible. All these little contrivances, and many more are necessary when one is trying to take a portrait of an ungrateful enemy. Numbers of my plates are under timed; but I am not particular. Those taken when the enemy had surrendered, and were unarmed, made better negatives, but 'circumstances alter photographs.'"

THE QUEBEC MORNING CHRONICLE
Monday, April 6, 1885

The North-West Expedition
(From Our Special Correspondent with "A" Battery.)

TEL-EL NEMACORENDA, C.P.R.—We, that is "A" Battery, left Quebec about 1 A.M. on Saturday, the 28th March 1885, with 110 officers, N.-C. officers and men, two field guns 9 pr. M.L.R. and 8 horses. "B" Battery left Kingston about 4 P.M. arriving at Renfrew, Ontario, about the hour that we drew up at the same station amidst the shouting of admiring crowds, backed up by the city of Renfrew brass band. "B" had about the same number of men with an addition of eight horses. The regiment now united made a total number of about 225 rank and file with eight officers, four attached officers, four guns and 24 horses. Since leaving Quebec we have been most ably managed by the different railway lines, and I doubt if ever better time was made or such good accommodation was supplied to troops as has been furnished by the C.P.R. on this expedition. The men occupied the new "emigrant sleepers," a wonderful contrivance for the comfort of a regiment continually travelling without any opportunity for sleep except what can be taken on the journey. By the foresight of the authorities we were not compelled to change cars more than once, thus we became a moving barracks. The gunners made tea for amusement, and chewed ship biscuit for exercise between stations, and were happy. At Carleton place we particularly enjoyed ourselves. Mr. Burgess, the proprietor of the refreshment establishment, served us such a meal that we unanimously declared that trying to smash Riel was far and away ahead of endeavouring to smash the Mahdi. Our train consists of 16 cars and on some of the heavy grades two engines were put on to hurry matters up. We are now (Monday 30th) getting along slowly on the construction road, and are shortly to arrive at our first gap or break in the rail. The whole gap proper is about 450 miles, consisting of fragments of nearly finished railroad connected by sleigh roads, which they say are fairly good.

At Biscotassing we found Mr. H. Abbott, who had a splendid meal ready for officers and men and placed his own car at the disposal of the officer commanding, Lieut.-Col. Montizambert, in which the officers had a sumptuous breakfast; the men's cookhouse was in a box car, were the men of the C.P.R. prepared the meals. I might here give details of the disposition of the regiment.

Officer Commanding the Artillery Field Force.
Lieut.-Col. Montizambert, R.C.A.

Field Battery.
Major Short, R.C.A., Commanding.
Capt. Drury, R.C.A.
Capt. Rutherford, R.C.A.

Garrison Battalion, Four Companies.
Capt. Peters, R.C.A., Commanding.
No. I Company, Lieut. Hudon, R.C.A.
No. II Company, Capt. Farley, R.C.A.
Lieut. Pelletier (attached), 9th Battalion.
No. III Company, Capt. Farley, R.C.A.
Lieut. Prower, 8th R.R. (attached)
No. IV Company, Lieut. Imlah, R.C.A.
Lieut. Chinic (attached), 17th Battalion.
Lieut. Disbrowe, Winnipeg Cavalry, (attached).

We are very fortunate in having Lieut.-Col. Forrest, who is acting Quarter-Master-General with us, and the few days start he got from Quebec has enabled him to have his arrangements, etc., regarding supplies in perfect order and we only hope he will continue with us, which is not probable considering the small army following in our wake. About 2 P.M. to-day we will take to our sleighs for a 54 mile drive, then we will camp in the snow, which is about three feet deep. This will make our time from Quebec just 60 hours, and considering the short notice, necessary stoppages, and new road, a wonderful record, and speaks millions for the C.P.R. this rapid work has been combined with the greatest comfort, from the start, ever experienced by the oldest soldier among us.

The Divisional Superintendents, Messrs. Spencer, Coyne and Marpole, passed us on from one to the other as carefully as though we were members of the Senate or a box of lamp chimneys. I will close this letter with particulars of the space between us and the finished portion of the C.P.R.

Biscotassing to end of construction (cars)
 148 miles.
Between camp half-way (march)
 53 miles.
Camp to Pt. Monroe (flat cars)
 80 miles.
Munroe to McKeller's Bay (march)
 20 miles.
Bay to Jackfish (flat cars)
 12 miles.
Jackfish to Isbester (march)
 20 miles.
Isbester West (flat cars)
 53 miles.

Further West (march)
 7 miles.
West to Pt. Arthur (flat cars)
 66 miles.

P.S.—Please don't complicate matters if a letter should turn up from my brother correspondent in the Soudan, as nude figures, sore eyes and drifting sand would not go down under the heading of the C.P.R. North of Lake Superior.
Foggy.

THE QUEBEC MORNING CHRONICLE
Monday, April 13, 1885

The North-West Expedition

(From Our Special Correspondent with "A" Battery.)

NEPIGON, APRIL 4—My last letter left us as we took to our first sleighs, at the end of rail. It was a task of no small account getting guns, stores and men loaded for the journey of 25 miles. The snow was fearful, being about 5 feet on the level and the slightest deviation from the road set horse or men almost out of sight. We got the long line off at last about 7:30 P.M. on the 30th, and your readers will judge our progress at the time of arriving, 6 A.M. next morning, 31st. The night was not dark, but it got very cold and the men suffered a great deal. Our string of sleighs consisted of about 60 double teams, and frequently the whole load of 8 men, the number for each, would turn completely over when the runners cut down into the deep snow. The chief cause of bad roads was owing to the track running on the top of the grade, which was not very broad, and consequently if the teaming was not perfect, a slew was unavoidable down the sloping sides. Major Short with his Field Battery was 17 hours doing the distance, and consequently the whole force was delayed till the guns could be got forward. After breakfast the garrison batteries got off again for the end of iron, distance about 15 miles. This was accomplished in good time, but unfortunately again the roads proved too bad for the guns, which were carried on the sleighs, dismounted, and nine hours were lost in covering a distance that on fair roads should have taken about three. By the time they were unloaded and packed on cars it was

4 A.M. on the 1st April, and all this time the men were keeping themselves warm in the snow by aid of fires. The thermometer was about 5 degrees below zero and we got off this rough piece of construction road, the only protection being about 5 feet of boarding to keep off the wind. It was a fearful trial for any men, but the regiment stood it like heroes and shivered it out for 10 hours. It was a lucky chance that the weather was no colder. About 3 o'clock we reached Port Monroe on Lake Superior, got our men and guns off the cars and after a feed went to bed, the men occupying the internals of a large schooner out in the ice. At this point our way lies by the ice along the cold and rocky shores of the lake, and it was a most novel and impressing sight to see the long line of sleighs with the live freight in front and guns, stores and ammunition in rear. McKeller's Point, 20 miles away, was reached about 1, when the regiment again took to the flat cars, while the heavy stores went on by ice, with heavy roads and the weather very cold. This proved one of our most severe trials, in some cases the teams literally gave out completely, causing stoppages for rest, when the clear sweep of the wild chilled the men to the marrow, but at last after midnight, about 1:30 A.M., the teams straggled into Winslow's Harbour, where the endless transshipping of guns and horses again took place, and when work was finished it was time for breakfast. Those who witnessed the pluck of all ranks working night and day in the wilderness of North Superior will, I think, be satisfied as to what a Canadian soldier can do. Many of them were played out, but without a word of grumble, squads of sturdy fellows tacked their troubles, never resting till all was finished, and then perhaps snatching a few moments' snooze beside a

camp fire, or on the floor of some of the shanties, or beneath the tents buried in snow. All I can say is that for myself I felt proud of being one of the regiment of Canadian Artillery. Capt. Drury, who went on in advance with the horses, made the journey from Port Munroe to "Winslow's Harbour," about 70 miles, under the most trying circumstances. It was necessary to get ahead to make some room. A short time after leaving Port Munroe a snow storm came on, drifting up the track so that the guide lost the way, and a great part of that fearful night they struggled on, alternately mounting and dismounting to keep from freezing. Frequently, a man would fall asleep and tumble off his horse, but the grit was there and the march was completed inside the 24 hours. The circumstances of the guardsman in the Soudan wandering away from his fellow into the hands of the enemy was forcibly brought to mind when our drivers in an apparently dazed manner wandered away from each other. It was simply the fact of the right man being at their head that prevented a casualty. In mentioning all this I should like to impress those who may take an interest in our welfare that nothing on the part of the C.P.R. was lacking, but that all officials connected with the Railway strained every nerve in order that we should enjoy all comforts possible. The feeding was better by a long way than anything we got in the midst of civilization. Lt.-Col. Montizambert's orders were speed; he knew his men and was quite aware that almost anything in reason could be accomplished. The drag on our movements of course was the Field Battery, owing to the frequent loading and unloading by the deep snow, almost impossible to wade through without any load whatever, but the idea of forsaking the guns never entered our heads for a moment. The scenery along the railway is imposing and a great change from the cultivated country of Ontario. One of the prettiest pictures is to look from the "caboose" at the tail of the string of cars over the heads of the men and horses at the engine charging some of the numerous tunnels cut through the grizzly rocks on the shore. It would charm the inventors of the present uniform and outfit of our gunners to see how thoroughly useless many of the articles are and how helpless a man is in the snow arrayed in what regulation lays down as correct. Luckily beef-boots were issued to all before they got as far as the end of the rail and the contractor's boots put up on barrels. This simply saved our men from freezing, for the tight, cheaply made boot, from the wet snow by day and sharp frost at night, would have been fatal. Even before reaching the hard work, many men, previous to the issue of the "beefs," turned out with stocking feet or with great slits cut at the instep to get the boot on. Regulation also requires a forage cap to be carried by the slight chin strap on the pack behind. After the kit has been taken in and out of a sleigh once or twice, away goes strap and away goes forage cap. The gigantic water bottle hangs by the victim's side. This is a most useful thing travelling in the snow as an "ornament" and "anchor." Water will freeze in them which cannot be thawed out as the cover is canvas. A tin cup would be of use. All have purchased toques which seem the favorite head gear. The tight, stiff, cloth tunic is fit for a parade at home, but is fit to increase the misery of a man in service. The poor officer also struggles to slip on over his necessaries the horrible cross-belt which no man has ever discovered the exact use of.

Numerous other cases go to prove the indisputable fact that following the Imperial outfit for Canadian climate, summer and winter, is a farce. It does seem strange that we wear, for service, exactly what the Imperial soldier would cast aside in the way of clothing if they were employed in this country, for we may say that the idea of a fighting kit is now recognized at home; and would it not be well for Canada, who cannot afford two outfits for her troops, to adapt the one most necessary for actual service. To-day, the 4th April, we have reached Nipegon, and have encountered the only hitch on our journey and I must say it is quite evident that someone has blundered. The number of teams was insufficient for even the transport of the baggage, necessitating three journeys back and forward for the stores. This distance was about eight miles, over an almost unbroken road. The men marched it and found it very heavy work. Fully 24 hours will be lost owing to this, and considering the warning of our approach the railway authorities should never have allowed it to occur.
Foggy.

THE QUEBEC MORNING CHRONICLE
Monday, April 20, 1885

The North-West Expedition
(From Our Special Correspondent with "A" Battery.)

NEAR TOUCHWOOD HILL, APRIL 8, 1885—My last letter was from Nipegon, if I remember right, but cannot be certain for our travelling was so rushed that it is most difficult to keep track of anything. Our work has been day and night, and here we are with General Middleton, which has been our object from the start; when we got off from Nipegon, after the long delay there, we almost flew by rail on to Port Arthur, where the whole place turned out to welcome us, and a fatigue party of the citizens headed by His Worship the Mayor boarded the train with two wash boilers full of the finest and hottest coffee ever seen outside of Java. The ladies of the Corporation followed and sandwiched the two batteries with ladies' fingers. Bonfires raged and threw their bright rays over us all as we smiled sweetly at the beautiful creatures who so lavishly plied us with good things of every description. The whole affair lasted fifteen minutes, when off we steamed bigger heroes than ever. Easter Sunday found us at Rat Portage and about 2 P.M. landed us at Winnipeg. Here again was a feast supplied by some of our old friends, who simply loaded us with favors and kindness. We left Winnipeg at 6:30 P.M. arriving at Troy or Qu'Appelle at 12:30 Monday. There we were divided—"A" Battery, with the half Field Battery, two guns, were at once put in their wagons and started for Fort Qu'Appelle, 20 miles over the Prairie, arriving about midnight, after a fearfully cold marching; the wind almost a blizzard with snow falling at intervals. It was a chilling introduction to the prairie, but on reaching the Fort, a most warm and comfortable house was given us. Left Fort Qu'Appelle at 9:30 A.M. for no place in particular except forward, and reached the only camp ground at 8:30 that night, when no firewood could be obtained which is one of the curses of these parts, so it was not a cheerful night for any of us. However, being too tired to work we rolled up in our blankets and slept fairly well, under our own tents for the first time. This morning, 8th April, after striking camp we reached the General's camp, where the 90th Battalion and Winnipeg Field Battery were under canvas, so the first real rest was indulged in, and the men amused themselves chasing "gophers," over the prairie and shooting rabbits, which appear to swarm in the little bush wood about; rabbit soup was the order to-night, and with my pony and shotgun, in a short run out of camp I put back with my animal loaded with chickens and hares, for our mess dinner. In the morning our orders are in marching order, no more wagon, except for stores, on for Touchwood Hills. Nothing is known of the rebels, as the scouts have not yet found their signs. Our front is well patrolled by them, who will prevent any surprise to the main body. The people here don't think there will be any fighting, but that the enemy will clear out. Before this reaches you, you will know more than I do at present. All the snow has gone except a few patches here and there, and despite the bleached grass and dried up bushes, the prairie is delightful. They were sowing wheat at Troy when we left there. We have just heard that "B" Battery are going with the other column to "Swift Current" and down stream, joining us at "Clarke's Crossing."
Foggy.

THE QUEBEC MORNING CHRONICLE
Tuesday, April 21, 1885

The North-West Expedition
(From Our Special Correspondent with "A" Battery.)

MIDDLE SALT PLAINS, APRIL 11—We have just got to this fertile spot, on which nothing will grow or thrive except ducks, owing to the scarcity of dry spots at this season of the year. The distance across it is about 45 miles, and it is necessary from its excessive badness to be equipped with firewood before leaving the shore of the prairie proper. The march to-day was terribly hard for the men as all the gullies were filled with water and soft mud, and to-night the column got in wet through, as far as the legs are concerned. We are forced to camp in the driest spot to be found, which is simply a bog, and how our gunners will put in the night is hard to tell. The conduct of the men has been admirable; a few were compelled to fall out, I think three, but only when they almost fell from exhaustion. I speak, of course, only for "A" Battery, who are with General Middleton's column. During the dry season water has also to be carried in crossing, owing to the impossibility to obtain any fit for use. We cannot really hear much regarding the rebels, except that Riel is at Batouche's Crossing. The idea is that none of them will fight, judging by their murderous proceedings among the poor settlers and priests, who have been ruthlessly slaughtered by the brutes. If we get the chance the friends of these most unfortunate people may rest assured that the whole force are determined to revenge, if possible, such horrible outrages. We will have a force of about 800 men when those behind get up with us. At present the column with its long train of baggage and supplies stretches away over the prairie, wending its course like a sick rattlesnake, dodging the pools and water patches in its track for two miles or more. Most of the officers of the staff and those mounted have sensibly taken to the prairie pony, and present a most laughable sight at first till the eye becomes accustomed to the thing, when the biggest corporations and the longest legs can amble along without even a smile from those on foot. The uniform of all ranks is equally startling, toques and pea jackets being the prevailing costume, with belts, etc., outside. We had several pow wows with different Indians, who one and all declare their loyalty to the backbone, but express at the same time how difficult it is to make the supply of pork keep body and soul together. They all speak well, and some of the swells are fine looking fellows, all Crees of the same tribe who are now assisting the rebels. The General has an interpreter who translates, by short sentences, the speeches which run as follows, and are all the same. The chief who wants to speak steps out in front of the others and spouts in Cree till he comes to a stop or comma. The translator has a peculiar way of his own and turns it into English in this shape: "He says his name, he says, is 'Old Man that Smokes' he says, and he says the land is big, he says, and there is room for all, he says, but, he says it is hard, he says to live, he says, unless, he says, etc., etc. He says," and so on. They all say the same. One old brave said that it would be cheaper for the Queen to give him pork than pay for all these soldiers. This was not a bad hit. I find that owing to the post going off shortly it is necessary to stop writing, so will beg to postpone report of progress till next letter.
Foggy.

THE QUEBEC MORNING CHRONICLE
Tuesday, April 28, 1885

The North-West Expedition
(From Our Special Correspondent with "A" Battery.)

VERMILLION LAKE, APRIL 15—To-night we are camped on one of the most picturesque spots that can be found on the prairie. The ground slopes away on either side of the camp and our picquets form an almost complete chain round the whole column. Our men have done some splendid marching all through, to-day getting over 23 miles of prairie, and are now—a half-hour after arriving—patrolling out on the open as outlying picquets. You will be able to judge that the work is no fooling, but—barring the fighting—it is soldiering of as stiff and trying a character as any enthusiast could wish for. Our average all through has been about the same, between 20 and 25 miles. In spite of all this, the fellows at night are happy as possible and generally sing themselves to sleep, to be roused at 5 A.M., and march at 6:30 next morning. We must soon know whether or not Riel will fight. The scouts have not as yet found out exactly where this worthy is situated. However, it won't be long before some news will reach us. To-morrow morning, the General with Capt. Drury and one filed gun, with 8 horses and a portion of "C" Company, are going rapidly forward, as we presume, to secure some of the scows, said to be on the river at some of the crossings, no one knows exactly at what place, but the idea is that Clarke's Crossing will be the destination— Batoche's, where Riel is, is considered dangerous, owing to the thick wood where we could be ambuscaded by the rebels. The 10th Royals are a few miles behind us to-night, with Boulton's irregular cavalry. When these arrive, our column will be complete. Otter's column started for Swift Current to-day, where they will cross the country to the river and come down meeting us at Clarke's. Our horses are in splendid condition, the veterinary surgeon stating to-night that he never knew of horses after all ours have gone through, on the north of Lake Superior and the work on the prairie, being so fit, and it just shows what care and attention to animals will do on a trying campaign.

FRIDAY, 17—We have at last struck the Saskatchewan at Clarke's Crossing, which brings us 196 miles from rail at Troy. This distance was accomplished in ten days, out of which we rested one day at Humboldt. Our average, therefore, for the nine days, has been about 21 ½ miles, which has been a great undertaking, when we compare it with ordinary marches made by modern troops, anything over 10 miles is considered great marching. General Roberts' celebrated tramp to Cabul only averaged 15 miles per day, so consequently our legs have passed for the best quality; at all events, let us hope our average will be in proportion. This high pressure is, however, telling on the men, but I suppose the necessity of rushing is great; if not, why an easier pace would have been more advantageous to all concerned. Yesterday the work was especially hard as the 23 miles were made against a gale of wind, very cold with flurries of snow at intervals. On arriving at camp those who had not given out were terribly fatigued and the equally cold night dragged through as we shivered in our tents, with no fires except enough to boil tea. The only wood available

was what we could pick up from old tele-graph poles that were lying here and there along the road. We are continually crossing the fast disappearing buffalo signs, of which nothing now remains but the tracings of their old roads and their whitened skulls. Three or four years ago the last one was killed and now they may be reckoned as almost extinct on British territory. We can really find out nothing as yet about the rebels. Their scouts have been around us at night, as we have seen their fires which flash up at certain points and then disappear suddenly, to be answered by others on the distant bluffs. There are no breeds here, and why they have not seized the scows for crossing and cut the wires is most surpris-ing. All sorts of reports are going, some that Riel is waiting with 800 or 900 men at Batoche's, other that he has only 200 all told, and again that he is a prisoner. You will probably know before this reaches you. We are getting very tired of the prairie, which is not beautiful at this season, with its frozen pools and leafless shrubbery. Of course travelling North makes it colder and more unpleasant as we go on, but it is likely that warmer weather is not far off. Our mess is the most important in camp, owing to the correspondents of the *Mail*, *Globe*, *Star* and *St. Paul Pioneer Press* being members of it. It has just turned out now that the officer in charge at Battleford, who has been making such a wail about his position, acknowl-edges that he is all right. It was owing to the frightened despatches of this hero that has started Otter's column off on what now turns out to be an almost unnecessary mission. If it is the case an example should be made of such a person. It is astonishing to see how quickly the clothing wears out, and if a renewal is not forthcoming soon the whole force will be unfit to ever appear among civilized people.

Foggy.

The North-West Expedition
(From Our Special Correspondent with "A" Battery.)

CLARKE'S CROSSING, APRIL 22, 1885—We are still encamped here, which makes four or five days without any advance, and the rebels only fifty miles off, at Batoche down the river. Transport of supplies for our horses has given out, owing to some cause which seems to be unexplained; the fact, however, remains that the animals have not seen an oat for a week. The want of some systems seems to prevail, and consequently just at the moment when we should strike Riel with the greatest advantage our hands are tied. As far as I can understand, the calculations required to explain the reasons are as follows: A load of oats, say 16 cwt., leaves Troy for 10 days' trip to this place. During the journey the team of horses eat up 8 cwt. and require 8 cwt. more for the return home; the army gets the rest. Apart from this excellent scheme of providing for the wants of our nags, the great salt plains are getting extremely hard (or soft) for travelling over, owing to the frost coming out of the ground, and for a month they will continue almost impassable. We luckily got over before the ground became too soft. At present our eatables appear to be plentiful to-day, when the pork gave out, rather a drawback, considering what a blessing such an article is to those out on the prairie. The few settlers about here are overflowing with gratitude at our coming, which they display in many ways, principally by charging us fellows for what we can get in the shape of bread, 50 cents per loaf; eggs, 50 cents per dozen, and other little blessings are retailed in the same way. So if the result of the expedition is attained, viz., the saving and protection of the squatter, we will return happy, but alas! Ruined. It is quite safe to say that the massacre of the whites on the Saskatchewan will not, at all events, raise the price of provisions. The poor little sheet iron box called a stove, in our tent, cost $10. And a water-logged fragment of rotten telegraph post was purchased from an over-obliging teamster for $1. After lighting, the temperature was high in proportion. The Saskatchewan is not pretty in any way, but similar to the rivers in the North-West it zig-zags its muddy course like a deep ditch, with a current of about four miles an hour downwards to the forks, where I suppose, it increases in depth and width. Here at its deepest point, it is only 9 feet. I had the pleasure of a long talk to-day with Mr. Kerr, one of the two brothers who were taken prisoners and escaped from the rebels. He appears a most clear-headed, clever and determined man, without any great dread of Riel and his followers, speaking of them with contempt. Regarding their organization and arms, he states that at present they cannot possibly, all told, be more than 250. He and his younger brother are the proprietors of a general store at Batoche's Crossing, where Riel now is, and from his dealings with the half-breeds has become fully acquainted with their doings. His first introduction to the people as rebels, was a few days before the Duck Lake fight, which took place about two miles from his store, when Louis Riel came into the shop, loudly demanding who was in charge. Mr. Clark remarked that he was. Riel then said he wanted all the arms in the place and ammunition, saying at the same time to charge

everything, as it would all be paid for. After this: they came in, selecting any articles they required on tick. The day following, Mr. Kerr went after some cattle with his brother, locking up his place of business. On his way back he met crowds of Breeds and Indians carrying articles of all descriptions which he at once recognized as belonging to him, and on arriving found that Riel's system of giving credit had proved too seductive to the public generally and a complete sacking of his establishment had taken place. He then put up at a house of a half-breed, and while there was arrested and taken before the Council charged with having given information regarding the movements of the rebels and having attempted to remove his own cattle away from Batoche. These charges were trumped up by two or three ruffians, ringleaders, desirous of getting out of the way any witnesses against them in the future, and who also owed Kerr money and had in their possession some of his cattle. No one will deny that these were sufficient reasons for seeking their death, but the Council released the prisoners, Riel himself being present. The Kerrs were placed on parole with a limit of five miles. Just after this the fight took place and from his account it was more of a scrimmage. A magistrate with some police with two guns, 7-pounders, met, in a narrow winter-road, a few of the rebels with Gabriel Dumont. They met and while talking the magistrate said he had come to arrest them and placed his hand on Dumont's shoulder, who raised his rifle and struck out. An Indian who was present at this attempted to snatch a rifle or revolver from one of the police, and was shot dead by another standing by. Then the fight began and lasted only a few minutes, during which four or five rebels were killed and two

of the whites, Dumont and his men ran back and were joined by Riel with the others who were coming on. Together they found the police putting their dead into their sleighs, and then Kerr says about 15 or 16 shots were fired, principally by Dumont himself, who is a good shot, and was apparently at close quarters. At this the police retired and the half-breeds did not follow. Next day Riel sent word to Crozier to come and bury his dead. Some white prisoners that were in the rebel's hands were then seized by the Indians to be killed in revenge for the death of the brave who fell at first. These men were rescued by Riel and protected from outrage. It would appear from the details that the affair was more of a scrimmage than a fight, as both parties apparently met with the idea of talking. Dumont, when he returned the second time, just out of revenge, and being a cool hand, shot most of the citizens and police himself, and only enough to satisfy himself. It appears strange that more shots were not fired the second time, and the half-breeds did not follow up their advantage. Kerr says that many of the rebels were terribly excited and frightened, and further is of the opinion that if Col. Irvine and Crozier had returned together they could easily have crushed the whole affair. The half-breed women all maintain that the business will end like the first Red River rebellion—by all the men running away. His description of Riel savors that of a religious crank. They have cartoons of him among the half-breeds as standing in the thick of the fight with the cross in his hand safe from harm. He boasts that with only his crucifix he defeated the police and will do the same with all-comers. Our wires were cut a few miles from camp last night, but whether the enemy did it or not seems

to be a mystery, so I suppose you will have us all wiped out until the repairs are made. We can't get correct reports for ten miles so your rumours must be startling. The western or left column is now camped opposite us across the river, and are now waiting like us for supplies to move. This afternoon Lord Melgund with some of the scouts struck some of the enemy's about two miles from camp (left column) and chased them 15 miles, the run was so hard, that our men tailed out with only two or three left. The rebels were joined by seven or eight more, so our men pulled up after wounding one of the enemy. Our orders are now out for a move in the morning and we expect the carts in to-night.

Foggy.

THE QUEBEC MORNING CHRONICLE
Tuesday, May 5, 1885

The North-West Expedition

(From Our Special Correspondent with "A" Battery.)

CLARKE'S CROSSING, APRIL 19—I have just time for a short letter, before closing of the mail. We have been here for two days waiting partly for the arrangements connected with crossing the river which have at last been completed. Last night three Sioux Indian scouts for Riel were captured by our men and brought into camp. They belong to the band of the chief "White Cap," and were, they say, forced by half-breeds to join the rising. To-morrow the Western force under Lt.-Colonel Montizambert, will cross the Saskatchewan, 23 men of "A" Battery, 2 guns of the Winnipeg Field Battery, the 10th Royals, 250 men, 20 scouts and 30 men of Bolton's Horse. The remainder of "A" Battery with two guns, the 90th Regiment, "C" Company, scouts and 40 of Bolton's Horse, will then proceed down the river, and try to cut off the rebels on both sides; this is I presume, the reason for dividing the column. My idea so far, from conversation with settlers, &c, is that there is some fizzle about the whole affair, and that Riel holds his men together with a very slender thread, plunder of settlers being a greater inducement than wrongs to be righted. I had a talk with one of the Kerr brothers who lately escaped from Riel. He is a blue-nose from Gloucester County, N.B.; I was quite glad to meet a fellow-countryman. Though threatened with death by the breeds he did not seem scared to any great extent, and it gives some idea of the feeling of security when very few of the inhabitants about seem to have rifles; out of seventy fighting men at Saskatoon, near here, only about twenty men have arms, therefore if the half-breeds inspired the people with any feelings of fear, they should, one would suppose, have a good Winchester along with the cow, pig and chickens. The three Sioux captured yesterday had only shotguns loaded with slugs. I hear a great many of the half-breeds are armed in the same way, and not all with the dreaded Winchester. Nor are they all capable of picking up a goose swinging at 600 yards or putting a scared rabbit out of sight. In fact they can't shoot as well by any means as the men who will be opposed them. This is my impression just now, which may turn out false, so pardon my foolish conclusion if it turns out to be the opposite. We had a most impressive service to-day, Sunday, Col. Grassett of the 10th reading the prayers and a glance round the square showed as fine a lot of bright, hardy looking fellows as any man could wish to command. The 90th have their band which cheers the men in camp beyond description and frightens the prairie ponies out of all their intelligence and instinct for dodging badger holes, and living on nothing. We have about 40 miles to get to Batouche's where Riel is; this will likely take two days and from there you may expect to get my next letter.

Foggy.

THE QUEBEC MORNING CHRONICLE
Monday, May 11, 1885

The North-West Expedition
(From Our Special Correspondent with "A" Battery.)

FISH CREEK, APRIL 25—My theory of no fighting has not, unfortunately, turned out correct, but the opposite has occurred, and though we have not been beaten, the fact of our having accomplished little or nothing will have a bad effect on the rebels, who will be emboldened to persevere in the struggle. As you know, the force was divided into two columns. Ours, the left, advanced yesterday from McIntosh's, intending to halt within a few miles of Riel and fight him to-day. About 11 o'clock yesterday, as we were marching gaily along through the first really fairly wooded country, we suddenly heard a volley in front and almost five minutes afterwards the General sent for the guns, so up we went to the front. There the advance guard were engaged, Capt. Clark, of the 90th, being hit almost at the first. We met several empty saddles on the way and the bullets were flying fairly thick about the men. We opened with shrapnel at a line of woods, where all that could be seen was a few patches of smoke here and there. The infantry gradually advanced, when the rebels dropped back into a deep coulee, where they were entirely protected. The guns then shelled some houses and set fire to some haystacks behind with common shell, but only a few people, if any, were in them. From the first of the fight the troops most recklessly wasted ammunition, simply firing at the woods and so the continual popping went on, while the enemy fired, to a certain extent, slowly. They did not shoot particularly well but hit our fellows as they crawled anxiously forward to get close, their only cover being the bare prairie behind, a slight undulating slope. The rebels seemed completely hidden, and no idea could be gotten of their strength, and not much of their exact locality, but all this time, here and there, the troops were being picked off—and though not showing cowardice there was an evident inclination to hang back, owing to the deadly effect of the unseen foe, and I am sorry to say that many of the officers did not seem to have that control and hold of the men that was necessary. After an hour's fighting the general decided to try and clear the bush and try and get a sight of the enemy. "A" Battery were allowed to leave the support of the guns, and with Lieut. Rivers and myself, we started at the end of the ravine, the understanding being that the 90th were to advance with us as they were off on the opposite side. As we advanced the difficulty of the sloping cliffs and the creek winding at the bottom became apparent. The left portion of the line, with which Lieut. Rivers and myself got, dropped down the bank, and crossed the brook where it was not deep. The rest of the battery kept along the brow and gradually were forced to incline upwards until they found themselves again on the crest of the ravine, and unable to get down to us. We found that the stream turned so that it was necessary to cross again in water quite deep; we rushed on as it was quite open and our only chance was the cover, so as at least to be on even terms. As Rivers and I tripped over the space, two or three of our men were hit and the moment we reached the edge down we flopped in genuine redskin style. Gunner Cook was shot dead beside me, Bombardier Taylor

was hit as I thought fatally. He threw me his rifle and ammunition, and said, "go on Captain." We now found how matters stood: the rascals were right in front, 30 yards away, and three times one fellow tried my head but missed, I am glad to say, neatly, but close enough for me to say for the rest of my life, that I know what it is to feel a bullet. We had three at each other, I firing at his smoke, but whether or not I succeeded any better is hard to tell. Rivers had the same fellow at him. Gunner Coyne, so well known, was at my side, and it will be some time before we three will forget this pleasant affair. Gunner Imrie was hit in the leg. Gunner Dolan had his sleeve cut open. Gunner Miller got a scar along his forearm, and gunner Langrill was shot through the arm by one of the lot that were popping at myself and Lt. Rivers. He behaved like the good soldier, and it was almost laughable. He had picked up an Indian blanket which he carried as a trophy, and laid beside him on the ground as he kept on firing. He saw the Indian and covered him, but Mr. Rivers noticing his breech open warned him, and as he lowered to close it the redskin shot him through the upper part of his arm. The first thing I saw was he spun round like a top and cried out "O, the B_____'s hit me, Captain," and quietly taking his rifle and the blanket under his arm, ran to the edge of the brook and quietly doctored up his wound. By this time we found that not one man of those who were to support us came into the wood but quietly remained on the other side of the stream; it was a most critical position. At last by drawing attention to some scouts on top of the cliff I managed to send a message to one of Captain Drury's guns, commanded by Lt. Ogilvie, to get his gun to the edge of the brow and take down the slope with care. It speaks well for the officer in charge as well as the men, when they loaded behind the crest and the men handled it to the edge not forty yards off the half-breeds. They got two rounds down this way, two of the men getting wounded, and the gun was hit several times. Under cover of this fire we retired, taking our wounded, but we were forced to leave one of the dead on the ground. We gradually fell back on the 90th and got under cover again. Our Sergeant-Major was wounded in the arm just as we started the rush; he is not seriously hurt. Gunner Houge had his rifle sling cut. Poor Demanolly crawled coolly to the edge of the cliff and was shot just as his head appeared over; the bullet entered his forehead. Both the A.C.C., Capt. Wise and Mr. Doucette, were wounded; the former had two horses shot under him, and the Major-General had the top taken off his cap, so it will be seen that a few good individual shots were among the enemy, and selecting the mounted appeared a pleasing pastime among them. The celebrated Gabriel Dumont was among them, for the interpreter advanced and asked if he was among them; the reply came that he was. It appears that their whole force was employed and in action; some say 400, some say 250, some say 50. As for myself I saw three or four men, such was their system of hiding. There may have been 200 but I don't think anymore. Capt. Drury shelled some of the houses, burning one down, from which a lot of horsemen ran off. The idea of properly fighting these fellows with the ordinary soldier, is apparent—naturally the militia cannot be expected to have the steadiness required so much. It simply requires men accustomed to the work, who know how to fight them in their own way. We will doubt-

less drive them before us as our force now united is sufficient, but chasing the wind is not satisfactory work. I omitted to say that, when Lt.-Colonel Montizambert's column heard the firing they secured that scow that luckily was coming down the river. They crossed and got in at about the tail of the fight, firing only a few shots. As the General did not think it worthwhile to dislodge those remaining in the thicket, after the action owing to the thick cover around us, we retired about half a mile to an open space and camped for the night. To-day we are preparing to cross the remainder of Lt.-Col. Montizambert's force, as the wagons and store, etc., are still on the opposite shore. It is painful to see our men clothed, equipped and armed perfectly unsuitable for this particular style of fighting the enemy. Their loose, invisible, bluff colored coats or dirty white blankets strike me at once as so much superior to our tight clothes, white belts and other appendages that are merely a mark for the rifles of the foe, and are carried simply because it is regulation, without any regard to its utility for service. It is only when a man gets a chance to see these defects and feel them that one is so forcibly impressed with the facts. One officer near me yesterday found his sword not of any great advantage while crawling through the brush, so he very sensibly threw it away and took to his revolver, the only useful thing for this work. Nearly all the officers have got ordinary pea jackets or something equally easy, for wear; but how easy it would be to construct a jacket for service doing away with so many foolish appliances. We will likely advance to-morrow. Some of the men under Capt. Young have just brought in four or five ponies, and a lot of cattle are wandering

about near the camp that we will shortly run in. It looks very much as if they were all retired and that we played sad havoc with them. We will know to-morrow at all events. Sergeant-Major Mawhinney was hit twice, but neither wound is serious; he will lose his thumb only. The doctors had hard work from the start, and went over the field no matter where and did their work heroically. "C" Company lost one killed, and six wounded. The total killed, 7; wounded, 43; 5 of these will likely die.

"A" Battery.
Killed
Demanolly and Cook
Wounded
Sergt.-Major Mawhinney, slight
Bombardier Taylor, back, slight
Driver Harrison, head, slight
Driver Turner, head, slight
Driver Wilson, arm lost
Gunner Imrie, thigh, slight
Gunner Armsworth, stomach, serious
Gunner Moisan, stomach, serious
Gunner Woodman, shoulder, slight
Gunner Langrill, arm, slight
Gunner Miller, arm, very slight
Gunner Ouellette, arm slight

FISH CREEK, APRIL 26, 1885—I must add to my letter of yesterday, which I forwarded rather in a hurry, and it did not contain the information regarding the upshot of the battle, which I am able now to furnish after our visit to the scene of the action. Last night about two A.M. we had an alarm and all turned out sharply, as the outlying piquets began firing. It was done quickly, quietly, and without confusion. In five minutes the Artillery camp was ready for anything. A few men with spades turned up

the prairie sod on one face, the other was protected by stores, camp kettles, etc., while the third and fourth faces gave protection to the riflemen, with the aid of piled saddlery. The affair, however, was of no consequence, but proved rather a source of joy to us all; it turned out to be the foreman of a train of thirty teams, anxiously expected, and which had in following us got astray, getting about 12 miles off toward Riel's camp at Batoche's. Here he had "corralled" his wagons and was searching about for us when he suddenly struck the enemy. He failed to reply, and so of course he was promptly fired on. He was quickly caught by some of the scouts, and relieved to find that friends instead of foes were his captors. This morning, with an escort of Boulton's horse, he proceeded to his wagons, and to-night they all returned bringing in about 14 rebel ponies. This, with the 12 we ran in last night makes quite a capture in the horse line. We also got about 20 head of cattle, which were cut up promptly for our hungry fellows and those cows giving milk were handed over to the sick and wounded.

To-day, Sunday, after Divine Service "A" Battery, the 90th and Garrison Gunners of Winnipeg Field Battery paraded for the purpose of examining the battle ground, and recovering two dead that could not be taken out of the wood. The "A" Battery man, Gunner Cook, who was shot dead in that trap so to speak, where two officers and 16 men found themselves, could not be removed when we fell back across the stream with our wounded. Of course, a thorough searching of the ravine took place and a sickening sight met our eyes: the whole was completely filled with dead and dying horses, some of them fine animals and all with their saddles on; they were laying in all

positions, many tied to trees and ripped up with shell and case. A most ghastly sight; we counted between 50 and 60 in this small space, some in the creek where they tumbled as they were raked off from the precipitous sides of the slopes. Indian blankets, head gear and different trappings were eagerly picked up as trophies of the fight. Only two Sioux Indians were found, but from blood spots and the number of horses it is certain that all dead half-breeds had been carried off during the night, therefore, making it difficult to tell the exact loss sustained by the enemy. Our idea now is that the half-breeds found our fire so heavy that they bolted about the middle of the day, which they could easily do along the deep coulee running for miles with its wooded sides away from the Saskatchewan into which it emptied, and left the Sioux allies to carry on the fight, which they certainly did like heroes and with deadly effect, from their almost inaccessible rifle pits dug in the sides of the cliff. Some of them, partly natural, were found large enough to cover even the horses which were killed by the nine-pounders in these holes, dug out, enlarged and even connected by what may be called covered ways. I was enabled to examine the spot held by the Indians, against whom "A" Battery were pitted in the bottom of the gulley and found not only were they under cover of the brink of the creek but had small pits cut out, giving them perfect shelter to themselves, and I wonder more than ever that our loss was not greater while our little squad were in this horrible hole. The last rounds were fired from the guns into the corner where the pits were situated, completely enfilading them, and must have made great havoc among men and horses. We found, strange to say,

that our dead had not been touched, which showed that those remaining when we ceased firing cleared out, only too glad to escape from the corner, which was impossible to do while our men surrounded it. It was surprising to see how well provided all the deserted houses about are with every comfort; and a picture of desolation was presented on viewing the interior of some of the shelled dwellings of the half-breed farmers. And one is impressed with the feeling that such apparently well-to-do people must be crazy to resort to arms. Gunner Armsworth, one of "A" Battery's wounded, died last night. The poor fellow was shot through the body. Gunner Moisan is also badly hurt, but appears better to-day. I think we have given the enemy a sharp lesson; and from what the breeds did on Friday it is not likely they will amount to much and the Indians if not backed up, will get tired of the business. I don't think it likely that any more fighting of importance will take place, as, again united, we are too strong for anything they can bring against us.

Foggy.

THE QUEBEC MORNING CHRONICLE
Thursday, May 14, 1885

The North-West Expedition

(From Our Special Correspondent with "A" Battery.)

FISH CREEK, APRIL 30, 1885—Still here on the battle ground and with no immediate prospect of getting forward, owing to certain circumstances that can only be altered by time. First of all the wounded cannot be left, and some would not survive a drive back to Clarke's Crossing, where it would be impossible to leave them without a guard. We are also delayed for want of ammunition, especially for the field guns, as it was not considered necessary to supply us with more than our limber boxes contained. I understand that after some strong representations of our condition it was hurried forward, and were it not for this delightfully misrepresented river, the South Saskatchewan, it might have got to us even before the fight. As affairs now stand, the steamer that left Swift Current about the 22nd has not been heard of, and it contains all the necessaries to enable us to push on, then bring matters to a crisis. From reports and information it was the idea of everybody that these steamers regularly travelled this noble gutter with certainty and precision, and though a longer time was necessarily taken in ascending the river, it undoubtedly carried the vessel like an express train, with the current; this was the popular conviction. But now after carefully sifting the conversation of some of its inhabitants, it gradually dwindles down to the conditions of water permitting. The beautiful uncertainty of water, influenced by the equally precarious state of the weather, will give one an idea of navigation on the South Saskatchewan. So far our land transport has been tolerably good, i.e., it has not broken down, for we have never as yet been short of provisions; had we depended on the boats the consequences would have been perhaps serious. Since the battle our scouts have been bringing in every day herds of cattle and ponies, so that the camp now presents the appearance of a large fair ground, and all night the oxen keep up their continual lowing, while the mules of the transport chime in and make night hideous. It is most satisfactory, however, that the weather is simply grand, and the effect therefore on the wounded is wonderful; many of the serious cases are up and moving about in the glorious sunshine and perfect atmosphere, feeling as they say better than ever. The surgeons say they could not believe that the climate would have such an effect, and maintain that the wounded men here if confined in a house would have been far from the same happy state that they are in at present. The surgeons behaved splendidly during the battle and did not hesitate a moment to take the most dangerous positions when required to do so by the poor fellows that fell. The correspondents also showed the greatest pluck, one in particular who was everywhere; his pony got shot, so he got off, took up a rifle and was alternately firing and taking notes from start to finish. I refer to the "Shooting Star." An American correspondent took up the rifle of poor Demanolly of "A" Battery, crossed his legs under him, tailor fashion, apologized to the General, hoping it was no infringement of international laws, and popped away side by side with our men. One little bugler of the 90s, a mere baby, helped some of his comrades up with

ammunition; he remained sitting on one of the boxes while, in the coolest and most ludicrous manner, you could hear his childish tones pipping out in the midst of the rattle of the rifles, "This way for Martini!" "Walk up this way for Snider ammunition!" One of the chief peculiarities of the affair was the terribly close ranges that the field guns were compelled to work at, owing to the nature of the ground and extent of cover held by the enemy. It was the greatest wonder that more of the field gunners were not struck or some of the horses, and this fact does not speak well for their shooting at moderate ranges, say up to 300 or 400 yards. The loss at the field guns would have been nothing were it not for the rounds of case fired right in the rebels' faces over the bank, in order to cover the retiring men of "A" Battery with their wounded from in front of the pits in the bottom. There is no doubt in the world but that many of the rebels made off early in the day, and all reports show that the bursting of the shell seemed to fill them with fear. It is to be regretted that so many untruthful sensational stories are daily appearing in some of the papers through the country, and all I can do is warn you not to believe them. Every little trivial incident is enlarged and sent straight off to the press, which gradually developes [sic] into a startling tale that only frightens the friends of those at the front and gives delight to the enemy. I must say that some of the reports of the fight were not as they should be, but on the spur of the moment, with the prominent object of getting the news forward, correspondents made the mistake of surmising what they really were not certain of at the time, and must now see was at least premature. For instance, after the firing ceased, about

3 o'clock, and the Royals had taken up their position after crossing the river, the General decided that the fight was over, which really was the case, as only a few Indians who could not get out were concealed in a few of the pits in the most secure corner of their position. It was raining slightly then and there was great prospect of a thunder storm coming on, hence it was necessary to camp in order to give rest to the men, and security for the wounded. Now the ground we held was right on the plateau as it were over their stronghold and on all sides of where the tents would extend was perfect cover, extending in all directions, which would give the best security to any adventuresome brave who would like a quiet thoroughly safe shot at the camp. The wagons and wounded were placed, in order to get as close as possible to the fighting line, right on the brink of another wood, and the idea of leaving them as could not be entertained, any more than that the camp should be pitched there. After a little search a spot was found a short distance to the left rear of the fight, entirely free from dangerous cover, and to this spot we proceeded, first sending the tents to be pitched, and finally the wounded, followed by the Royals and 90s. From my tent door I can now see portions of the gully and one of the houses occupied by the 90s after the rebels fled, about 700 yards away. This will give an idea of the distance. As our last men retired, a few horsemen who were skulking in the woods behind the shelled buildings across the ravine, appeared and jeered at us, of which no notice was taken; these fellows, of course, saw us camp again in full view. To a military man this did not appear formidable, but unfortunately it struck some of our correspondents differently, and they reported, or

at least gave the impression that General Middleton had retired to the river, which we will call the first false idea given of the business. In a military sense it was nothing of the sort, for often, no matter how sweeping a victory a general may accomplish, he would commit a grave fault were he to risk the repose and rest of his army, and especially the wounded, by camping on any ground where one or two roving rebels might, without any actual harm to us, keep our whole force on the alert through the night, depriving us of sleep, and worrying an unhappy fellow who unfortunately lay bleeding on the prairie. Retiring and selecting a suitable camping ground, with the objects mentioned above, are two very different matters. No object was in any way to be obtained by staying where we were, as all the enemy had retired out of their position with the exception of a few Indians, (I don't think more than 5 or 6), who could not get out and certainly were fighting at bay, only firing a stray shot at intervals. We now come to the point of not having cleared them out. If this had been done the whole report of the Battle of Fish Creek would have been changed. The Royals came in fresh from the opposite side, and the gully was almost empty. In order not to risk the chance of losing another life they were not allowed to go through, and thus the truth of how thoroughly our opponents had disappeared was not known absolutely till the second day after, though surmised on Saturday, when the cattle were seen to be wandering aimlessly about. Had the Royals, who were fresh and burning for the fray, gone in when they arrived the probabilities are that a man or two might have been hit, but the gully could have certainly been cleared, all would have been impessed with the genuine nature of the victory and a most necessary confidence have followed to encourage our troops in any future fighting that may occur, and more especially our correspondents would have furnished our anxious relations and friends with an entirely different description of Fish Creek. The two dead left in the bottom would have been recovered, the loss of the enemy known, to a certain extent, and we should have retired under our blankets feeling more satisfied than we did on that memorable evening. The few brave Indians who held out of the last must have left in a hurry, as they took nothing with them belonging to us and left many trophies on the field. It was curious to find beside some of the pits many small piles of clay bullets, evidently made when they got short of the lead ones. Some appeared to have been made on the ground, being soft, while others were quite hard and had been, no doubt, baked in the houses, where some were found afterwards. Several of the breech-loading shot cartridges had two bullets in them, which did not improve their shooting. My next letter will likely have more information than this, which is only remarked on the already reported battle and therefore cannot be very interesting.

Foggy.

The North-West Expedition
(From Our Special Correspondent with "A" Battery.)

FISH CREEK, MAY 4, 1885—I am getting tired of Fish Creek and so are we all, for there is nothing in the world to do. Going outside the lines is forbidden without a pass, and now that the wolves and crows have almost finished the dead ponies in the gully there remains next to nothing to see, so we fiddle around camp and have constructed various little contrivances that are most useful. As all our forage caps were lost on the way up, we have constructed out of cut up flour bags, a most serviceable and invisible skull cap for the officers and rank and file. They have been dyed in tea and match the dry prairie grass beautifully, while at the same time it gives the battery a most smart and dashing appearance. Our ovens have been constructed and the bread that comes out of them, though heavy, is excellent and fills the slumbers of the men with pleasant and homelike dreams of the Citadel. To-day a cricket match took place between "A" Battery and the Winnipeg men; we scored 87, while they made 16. The wounded have arrived safely at Saskatoon, where they are provided for and stood the journey remarkably well. Our serious case Gunner Moisan, displayed great pluck and will get well in all probability. Today the General, Lord Melgund, with Boulton's horse and the scouts, got up to Gabriel's Crossing, about eight miles from here. Everything was deserted, including Mr. Gabriel Dumont's house in which they found a very nice billiard table, and all the other buildings about showed the prosperous condition of the people, who left most of their farming utensils behind them, with a lot of the cattle, which were appropriated by our men and brought in. Mr. Chambers of the *Star* and Ham of the *Mail* also accompanied the escort, so you may look for most reliable information from their papers, as they are always to the fore in everything, and display the greatest energy in working up information. The former had his horse shot in the battle, but he revenged himself by potting all the enemy's ponies in reach for the rest of the day.

They found a picquet of Riel's in one of the houses, about half a dozen fellows, who cleared out before they got in range. They entered the house and found the remains of a meal that smelt like "horse." It is just as well, for we prefer the steers. They also found a number of bloody bandages, for which it is safe to say they can thank us. All indications go to prove that it was a terrible stampede on the day of the fight, and had the Royals only gone through the gully that night what a different story would have reached the papers of Canada, and many anxious heart would have been spared the misery of the idea that he had been beaten. It is simply disgusting for us here to-day to read some of the papers just arrived from the south regarding the affair. Some of the most revolting statements are paraded under the glaring headings of "Defeat," and deliberate falsehoods are printed without any foundation whatever, which not only mislead and distress our friends at home, but furnish the best possible information to Louis Riel and his blood-thirsty allies. Many of the stories are concocted by unprincipled rascals who pick up straggling reports and mould them to suit their purposes regardless of consequences. Therefore all should

rely only on the reports of those respectable papers that have their representatives with us. The "Northcote," the steamer from Swift Current, is expected in every moment as she is reported a few miles up the river. She has the Gatling on board with a large supply of stores; we are also looking forward with the greatest pleasure at having Lt.-Col. Straubenzie, where his known experience and dash will give the greatest confidence, and he cannot fail to be of the greatest assistance to Gen. Middleton. I have succeeded in taking many valuable photographs, two of which were done during the battle, the first I think on record. We will likely advance tomorrow or at all events next day.

To prevent any mistake regarding our casualties, which I see by some papers is not correct, I repeat what was before reported—three killed and 12 wounded, making 15 in all, nearly one-third of the total loss of the force engaged. This is pretty severe, considering that 30 of our men, with Lt. Hudon, were with the other column across the river.

Killed:
Demanolly,
Cook,
Armsworth.
Wounded:
Mawhinney,
Taylor,
Moisan,
Mellor,
Ouellete,
Woodman,
Imrie,
Asselin,
Wilson,
Harrison,
Turner,
Langell.
All slight except Moisan. Wilson lost his arm.
Foggy.

Letter to Lieutenant-Colonel W.H. Cotton, Commandant, "A" Battery, Regiment of Canadian Artillery

My Dear Colonel,

We have at last got a big victory, more by good luck than good management for by some fluke the d____d old fool of a General could not stop old Straw when he got the men going. Of course, to start with a more helpless idiotic old imbecile never existed than the General. On the first day we went at them and as usual before he got his infantry out he rushed up the guns on an exposed spot close to some pits and they just got out of the way in time to save the gunners and horses. I was in charge of the support (our men) and so we found ourselves right in the hot spot and as it would have been foolish to give it up we held on as the 9prs went back and the Gatling came up. I eventually had to clear out also, but we hung on and so lost poor Phillips, with [handwriting illegible], Fairbanks and Charpentier wounded. Stout was hurt with the Gatling. We thus held the extreme left of the position, and did so for most of the day while the Indians and Breeds kept shaving the tops of our heads all the time, and though hardly as close as Fish Creek I had some narrow shaves, as I was mounted and only by keeping well on the move managed to escape. Hudon behaved well. Coyne as usual was a tower of strength to the men about him, and when we got back eventually he ran up with Beaudry for Phillips' body only as an old soldier would do. The general as at our first fight would not rush anything but went about giving no orders any body could understand, simply appearing helpless. The end of it was we camped just behind the Church and in order to do this we had to fall back the men who were in the fighting line—and of course the enemy whacked into us pretty well, coming close to our Zareba, but meeting a good fire they disappeared for the night. Next day he put the fellows out again and as far as the church, where all day the firing was kept up, during which tons of ammunition was wasted by our troops most foolishly. As night came on the General of course withdrew his men to the Zareba and the same thing as before was repeated at night, the rebels following our fellows up to the works but doing very little damage, a few men being hit. This style of masterly tactic went on for the third time, and that night there was some pretty strong expressions in camp about the state of affairs. The way our men fired in retiring must have been a jolly good joke for Riel, for they simply poured in the lead as they fell back. On the 4th day we did not go out in the morning, which must have given great comfort to the enemy, and they were evidently preparing for the night circus as usual. About 2 the General told Straubenzie to take out the men and push up to the Church again and try if possible to get far enough on for the guns to shell Batoche. They went out in a desultory sort of a way but presently those left in the Zareba including our battery heard a big cheer, followed by a volley from the enemy. This seemed to start the affair. Other companies were sent out, and away went Straubenzie over the brow with Young of the Winnipeg Battery his Brigade Major assisting him. Gradually the whole lot took up the cheering and out went the Gatling. Three field guns followed. The rebels in the first pits bolted, being mostly "White Caps" Sioux, and then

began the fight in earnest. The enemy were seen to leap from their cover and go, which gave the troops something to see, so they yelled and followed like hounds, while any little stop or hesitation brought Straw up behind who sent them along, Grassett and Williams leading on their men in a good spirited way. As they reached the houses, the stampede of rebels was general from the pits all along the hillside. They left everything, coats, blankets, pots, pans, kettles and things of every description were found in their works which appeared to have been their abode for some time. You can't imagine the fun in the Zareba as the fight gradually assumed large proportions, ammunition was piled forward, shovels, spades or picks we chucked into the carts and galloped to the front to secure what we had gained and I had my hands full looking after the Zareba, as very few men were left to protect. The rush and cheer which we had all been begging the General to allow had taken place contrary to his directions and so the thing was done, for which he assumed the whole credit when he got back to camp. To make matters more perfect the steamer that had run the gauntlet down had arrived from below in the evening with another full of stores, and so everything was perfect. You could not imagine what a splendid position Riel had and how beautifully his pits and covering was made in which his whole force lived. The steamer had a hot time on her passage past Batoche although she was to a certain extent protected. 3 men were slightly wounded and her smoke stacks carried away. You will see that the total loss of the four days does not come to much more than half that of "Fish Creek," while the amount of lead fired by the Militia was fearful and ridiculous. The enemy used to hold up a coat and after a whole company would open up on it they would be seen to fish out the lead from the bank or face of their pits. They resorted to all kinds of bullets and there is not the slightest doubt but that our men gave them a quantity of lead to return to us again. We have now got all the prisoners in camp, some of them wounded including several of Riel's council. It was fearful to see how the Gatling struck several of the rascals and what horrible wounds were inflicted by the snider. Will you write Col. French about his brother Jack? We are all awfully sorry—and tell the Colonel I was with him a great deal just before he was killed, he was shot from the outside of a house in which he had rushed with his fellows—the scouts. I want to get home when I can, don't fail to do what you may be able to get me there. I will exchange with Wilson if he wants to go to B.C. for it would upset my affairs to go straight from here to Victoria, in fact I could not do it.—JP

The General has ordered no more correspondence. As I can't write the *Chronicle*, tell Stewart I have got what ought to be splendid photos taken during both battles. Did you see that I divided the first prize for "Animals at Home" given by the "Amateur Photographer"? The weather is simply delightful, we have slept in the trenches for 4 nights now most comfortably. All our wounded are doing well and will be right shortly. I wish you could see me now with whiskers and dirt but happy and well fed.
—Kindest regards to Mrs. Cotton

Yours,
J. Peters

THE QUEBEC MORNING CHRONICLE
Friday, July 10, 1885

Hunting the Bear
The Scene of the Frog Lake Massacre
Marching and Counter-marching
The Release of the Captives
Welcome Remembrances from Home
Errors Regarding the Battle of Batoche
(From Our Special Correspondent with "A"
Battery.)

As stated in my last letter we left the morning after arriving at Fort Pitt from our abortive effort at Loon Lake, where the impassable swamps arrested our progress. We reached Frog Lake, the scene of the massacre that night, the 13th of June, where we camped for the night. It is an extremely pretty spot and must have been a most thriving settlement till that fatal day in April, when the entire population of whites, nine or ten in all, were assembled in their little church for service. While the congregation were kneeling at their devotions the "Wandering Spirit" one of the "Bear's" councillors and friend of Riel's, entered in his war paint, rifle in hand, and knelt with seeming devotion in the aisle of the sacred building. We all know what followed, as the settlers dispersed after the service. Not even the priests were spared but ruthlessly shot down by the friends and allies of Louis Riel, the patriot, whose course is now being applauded by certain people in Lower Canada. Had these supporters and sympathizers of the arch rebel but heard the dying wail of the little colony, and viewed the ghastly remains of the dead, perhaps their desire to save from the rope the instigator of such outrages would not be so determined. The Midland Battalion who were camped there

have erected crosses and rudely decorated the newly made graves with the greatest care, and were it not for these rustic monuments and charred remains of the buildings no one would believe such atrocities had so lately been committed. Frog Lake is about 30 miles from Fort Pitt, and the next day we set out for the Beaver River, 45 miles, and before night reached a point about 5 miles from it and camped, marching into Gen. Strange next morning. Here was found a band of Chippewayan Indians, who had deserted Big Bear after the attack of Strange; they had given up their arms before we arrived. Gen. Middleton promptly selected two of the most intelligent and, with promise of reward, despatched them in search of the whereabouts of the enemy and any information regarding the captives. Orders had been sent some days previous to Otter and Irvine to also proceed north, the former in the direction of Turtle Lake and the other towards Green, so as to ensure the capture by surrounding the quarry. As events turned out, this had the desired effect, and though the rascals have not as yet been taken, they became so awakened to the fact that it was getting hot, that they released Mr. McLean and the others, who are now returning on our old trail made to Loon Lake. We remained here, obtaining

A MOST WELCOME REST

for ourselves and horses for two days, waiting for developments. On the night of the 18th news came from Otter that he had struck Big Bear's trail near Turtle Lake and while we were discussing how the wiley old savage had suddenly altered his first course from north to east, our two Chippewayan scouts came into camp with the welcome news that all the prisoners were free and making their way home. The General ordered canoes to be

sent off by the river for assistance and also wagons with food and clothing via the trail to Loon Lake, as the poor people were reported to be much fatigued and in need of comfort of all kinds. On the 19th again we were off on our back tracks to Pitt. The general himself starting about 2 A.M. and reached Pitt that night, 75 miles, not a bad example to some of the younger men in his column. The column took two days, 46 miles on the first and the remaining 80 on the 20th. There had been a great deal of sameness regarding our rations, on both our trips after the Bear, flour and bacon being the staple articles, and our delight can be pictured when we found some of the good things from our kind friends at home awaiting us. Never before did little delicacies seem so delightful. We sat up the entire night with canned fruit and essence of coffee. The Quebec papers were awaiting our arrival and the men of "A" Battery were

TERRIBLY DISGUSTED

at the portion of the description of Batoche where the Midland Battalion are represented as having rescued the body of our poor Phillips from the cover where he had so gallantly fallen. Like many other gigantic falsehoods that have made their way into the papers it is utterly untrue. And for the benefit of our friends in Quebec and elsewhere, I wish to state that whatever faults we may commit, that of allowing others to rescue our dead from a dangerous position is not one of them. The spot where Phillips was killed was a most deadly one, and after he fell there, no one was able to occupy it. When we were about to camp it was necessary to get the body. I went with Gunners Coyne and Beaudry, to the edge of the crest on the exposed side of which in some light cover the poor fellow lay. Beyond this I did

not go, but left it to braver men, the two mentioned above, who deliberately crawled forward and at the greatest risk of their own lives were enabled to grasp the feet of the corpse and so crawling backwards brought their dead comrade in. I do not mention this in any boasting spirit, but simply state the fact that the only men who went over the brow wore the same uniform as that of their poor comrade, and shining on their shoulders the letter "A" must have shown

THE ENTERPRISING REPORTER
FROM WINNIPEG

if he had been there, that no red-coat was even in sight at the time. This is no reflection on the gallant red-coats, who are equally annoyed at such a mistake, and I feel sure they will give us credit for simply doing our duty. I may add that the General himself was near at the time, and understand that he has mentioned the act of Coyne and his comrade officially. One is not surprised at such trivial mistakes, when such a widespread delusion is now in the minds of so many. I almost fear to refer to it, and the "cold steel" advocates and sensational war correspondents will never believe, that so far I have failed to discover either officer or man who actually saw a fixed bayonet during the celebrated charge; the bayonet was there, but alas! It hung in its customary and highly useful position by the soldier's side, where it playfully tripped him up and impeded his progress as he chased Riel's soldiers, who never waited for anything but the bullet. Some absent war correspondent, or mutilating telegraph operator, could not resist the word

"BAYONET,"

comforting himself, I suppose that the word "charge" should have a bayonet before it. I am glad to say that none of the gallant

fellows was foolish enough for the sake of making a good paragraph, to fix his useless bayonet in the vain hope of any breed or Indian waiting for a prod. We will never hear of a true bayonet charge against our North-West Indians. There are many other ridiculous fables connected with Batoche, which for the most part are harmless, but at the same time the affair was quite glorious enough to merit a true and correct report; but alas! Our papers require that all despatches should be served up hot, and such slight deviations from the truth as a harmless bayonet, did not appear to be anything out of the way. Consequently the glowing headings appeared and an unheard of number of copies sold without any injury to our troops or Louis Riel and his allies. Foggy.

THE QUEBEC MORNING CHRONICLE
Tuesday, September 8, 1885

Notes and News.

CAPT. PETERS'S PHOTOGRAPHS—
(*The Amateur Photographer*, London.)
We are all regretting that poor Cameron, of the *Standard*, was killed so early in the Egyptian campaign, for, had he lived, we should, in all probability, have had some photographs of a battle taken under fire. He was plucky enough to have performed the deed. It has fallen to the lot of Captain J. Peters, of the Citadel, Quebec, to be the first to obtain photographs of battles taken actually under fire. The gallant Captain's interesting letter to us on the subject we publish in its entirety elsewhere, for it becomes historic. He informs us that he has obtained about a dozen splendid photographs taken during the battles of "Batoche," and "Fish Creek"—all under fire, and one of these was obtained, *mirable dictu*, during a volley from the rebels' pits, about 150 yards distant.

The late rebellion of the North-West of Canada brought into the welcome light of publicity the splendid qualities of our soldiers, and the strength and powers of endurance of the volunteers. Had there been no rebellion, the world would not have known of what stuff our Canadian Brethren were made. The accounts which were published at the time of the forced marches, of the pluck and heroism displayed alike by men and officers, were read with great attention and admiration in this country. Private letters in abundance more than testified to their coolness, courage and intrepidity. The real history of how the Canadian rebellion was crushed has yet to be written. It will be read like a romance of the days of chivalry. But among the many noticeable exploits characterising that short but sharp campaign, by no means the least important is the coolness displayed by Capt. Peters. While bullets hissed and spluttered around and overhead, and while men were falling wounded or struck dead, this photographic hero, with extraordinary nerve, coolly focussed, capped, inserted the dark slide, drew out the shutter, uncapped, capped, pushed in the shutter, and put up the camera. When one thus enumerates the many and delicate operations required in the taking of a photograph, Captain Peters' exploit appears a little short of the marvellous.

To congratulate Captain Peters is unnecessary. He is known to our readers. He took one of the prizes for "Animals at Home," when among the photographs which he submitted were such subjects as the "Bear at Home," and the "Bear at Bay." These speak for themselves. The pluck and coolness displayed in the hunting field made us know what manner of man he was. But now he has outdone himself. We hope to receive copies of these battle photographs for reproduction.

THE TORONTO MAIL
Tuesday, May 26, 1885

Riel was allowed out of his tent this afternoon for a few minutes, of course escorted by a guard. He had scarcely left the tent when the ubiquitous Cap't Peters of "A" Battery, who is an amateur photographer of no mean order, had him "taken." Riel looked askance at the instantaneous camera, perhaps fearing that it was an infernal machine, but as it didn't go off he walked back into his tented prison apparently well pleased. Cap't Peters, it may be mentioned, is an enthusiast in the photographic art, and his negatives of both the battles of Fish Creek and Batoche's; the first it is claimed ever taken as an action.

THE QUEBEC MORNING CHRONICLE
Saturday, June 20, 1885

PHOTOGRAPHS IN ACTION—Mr. Livernois, photographer, of this city, has received from Batoche a cartridge box full of photographic plates addressed to him by Capt. Peters of "A" Battery. These plates were taken by Capt. Peters with his portable camera during the progress of the fights at Fish Creek and Batoche's and represent the troops in various phases of the actions. The plates are considered very valuable, as this is believed to be the first instance on record of photographs of battles in progress. Capt. Peters has copyrighted the plates in question, and they will no doubt be found very interesting from a military point of view.

THE TORONTO MAIL
Thursday, January 29, 1886

Captain Peters is about to publish a certain number of albums each containing over 50 of his instantaneous photographs of the North-west rebellion with a description of each picture.

A certain number of albums containing at least fifty with a description of each, will shortly be completed. Those wishing to secure them will kindly send their names and addresses TO CAPTAIN JAMES PETERS, CITADEL, QUEBEC. When ready the albums will be forwarded C.O.D. Price $10.

PHOTOGRAPHS TAKEN UNDER FIRE

All of the photographs in this section were taken by James Peters, except for those by William Imlah (see Appendix B). The captions are Peters', as they appear in the Captain James Peters Album 1, donated to the National Archives of Canada by Peters' son Frederic Hatheway Peters in 1958. Labelled "1885 N.W. Rebellion Views," these images occupy pages 29 to 46. Here, each image is labelled with the three-digit number assigned it in the album; the caption, as found in the album; the Library and Archives Canada cataloguing number for negatives that were made upon request and later digitized. The numbering system in the album does not appear to follow a particular chronological order. The archival numbers represent the order in which negatives were requested.

There are at least two other copies of the photographs in existence. There is one set in a presentation album given to Minister of the Militia and Defence Sir Adolphe Caron, held at the Royal Military College Library in Kingston, Ontario. It contains sixty-two images—the ones I assume Peters judges to have been successful. There are also eighty photographs in an album held by the Glenbow Museum in Calgary, Alberta.

The order of the photographs is of my own choosing, since none of the albums available for scrutiny has any discernable narrative order.

Cataloguing information from Library and Archives Canada:
 Frederic Hatheway Peters collection
 Captain James Peters album 1
 1884–1885.
 1 album.
 Restrictions on use/reproduction: Nil
 Copyright: Expired
 Credit: James Peters / Library and Archives Canada

689
First of Fish Creek.
C-003459

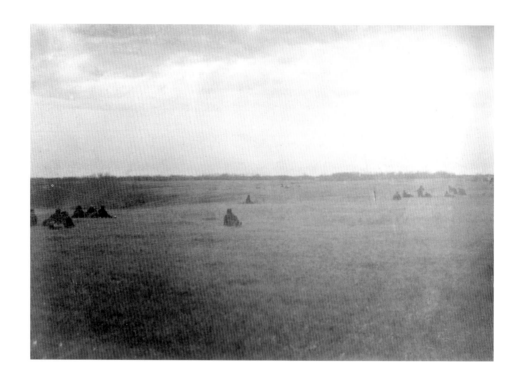

726
Fish Creek.
C-018110

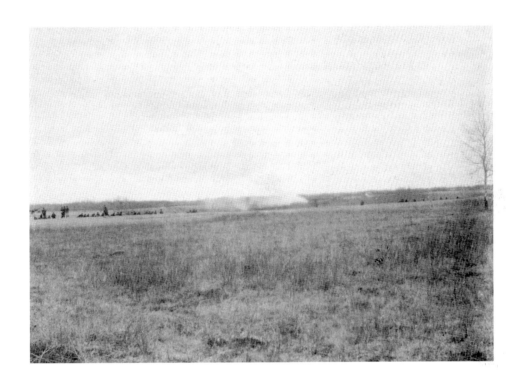

667

Limbering Up at Fish Creek.

C-004590

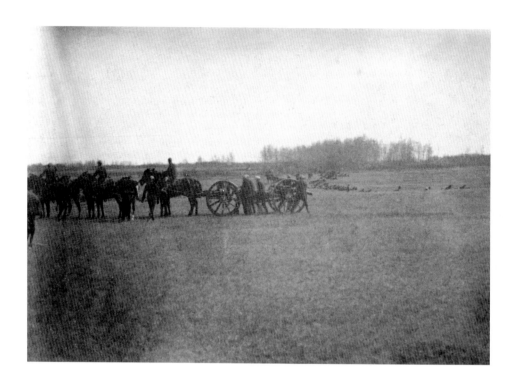

685

Firing the First House at Fish Creek with 9-pounders.

C-004521

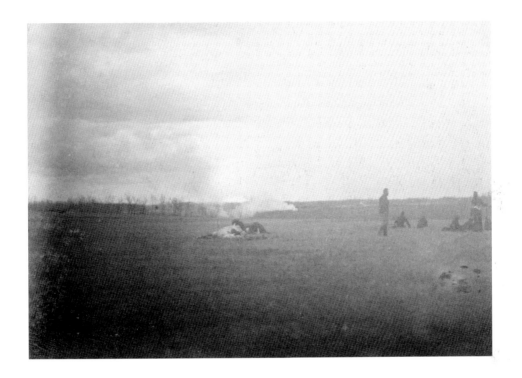

675
"A" Battery Supporting the Guns.
C-003457

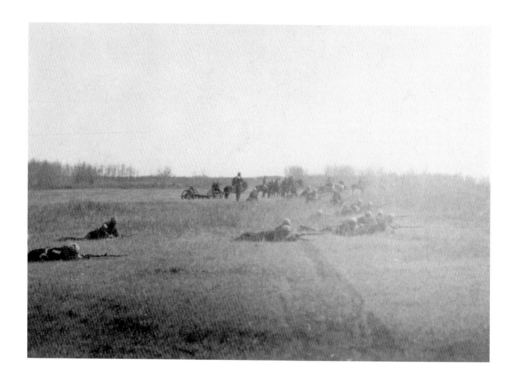

622

Front of Rebel Position.

C-003456

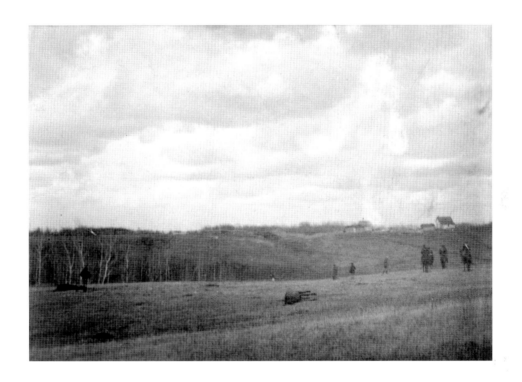

670

Grenadiers Relieving the 90th, Fish Creek.

C-003455

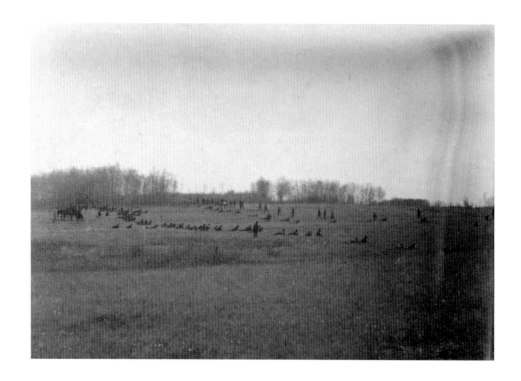

686
Driving the Rebels Back.
C-018965

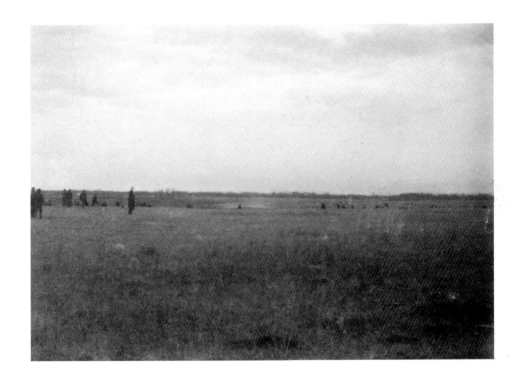

634
Rear of Rebel Position.
C-018936

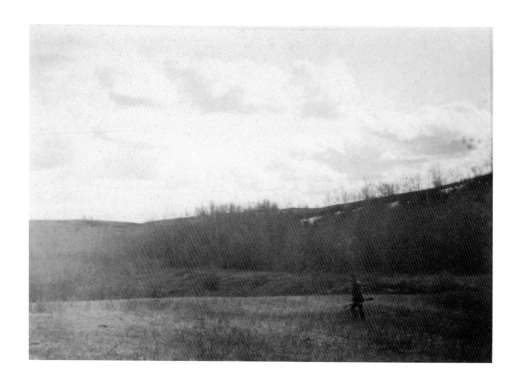

665
Rear of Rebel Position.
C-018941

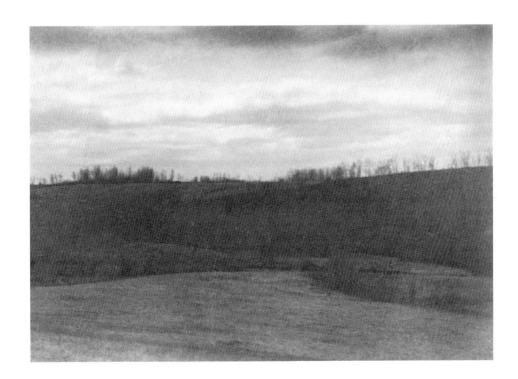

635
Rear of Rebel Position Where Ponies Were Killed.
C-018937

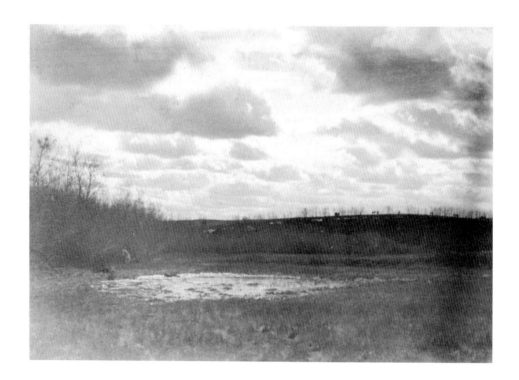

687
After Fish Creek.
C-003460

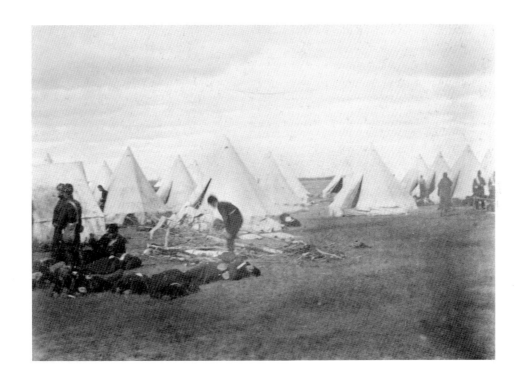

691
Burying the Dead.
C-003458

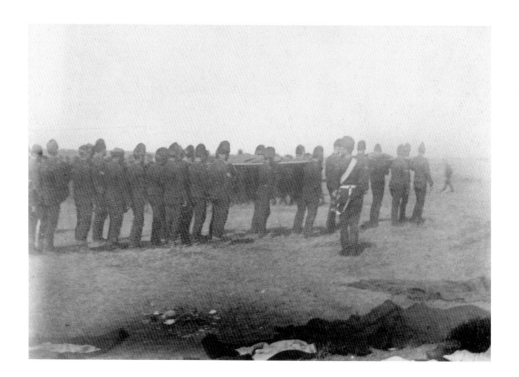

693
Sewing Up the Dead.
C-004520

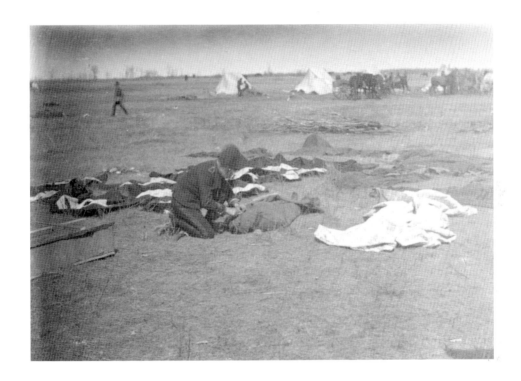

632
Some of Our Wounded.
C-018935

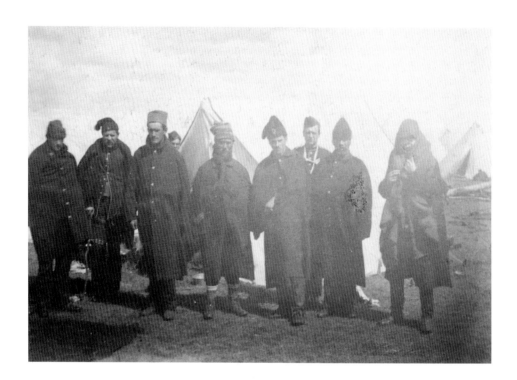

631
The General and His Wounded Aides.
C-003453

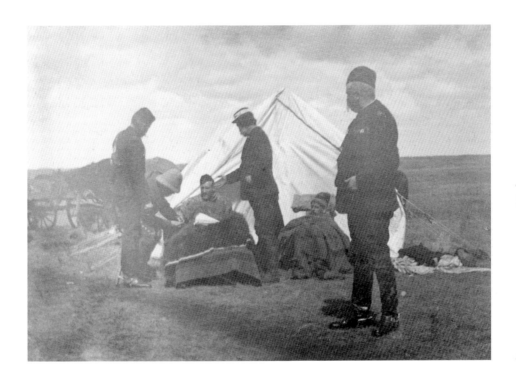

674
Métis Women.
C-018943

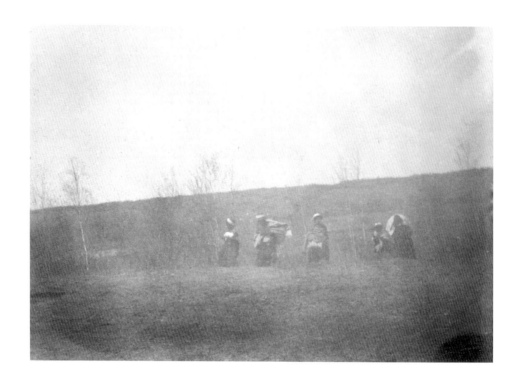

682

Refugee Camp, Fish Creek.

C-018944

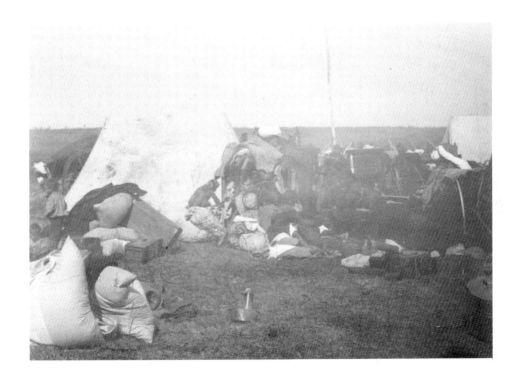

702
Wounded Leaving for Saskatoon.
C-018584

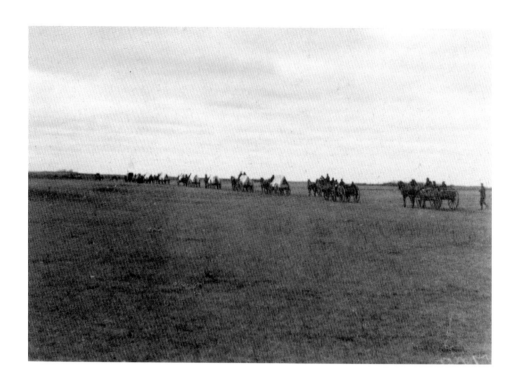

618
The Big Guns.
C-018930

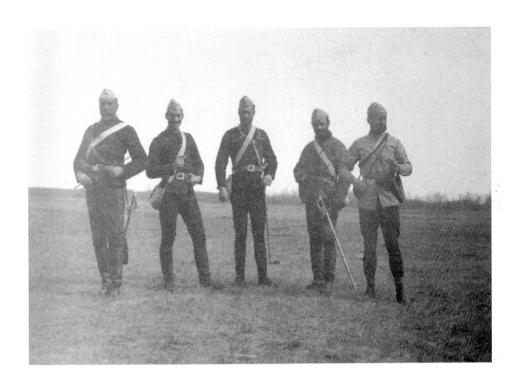

688
Camp at Fish Creek.
C-017609

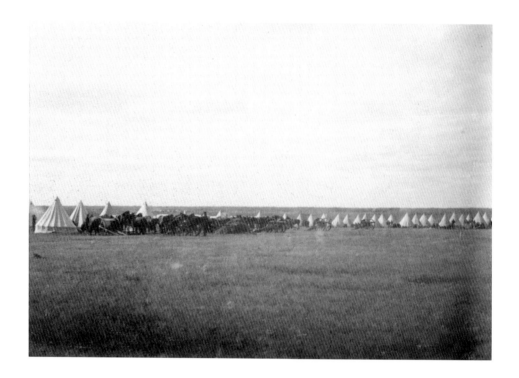

694
Shelter Trench Exercise.

C-018946

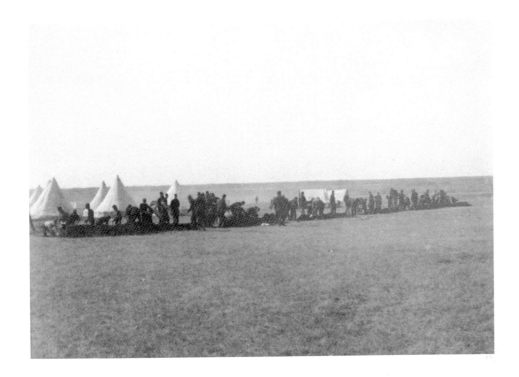

633

Rebel Scouts Captured Before Fish Creek.

C-004591

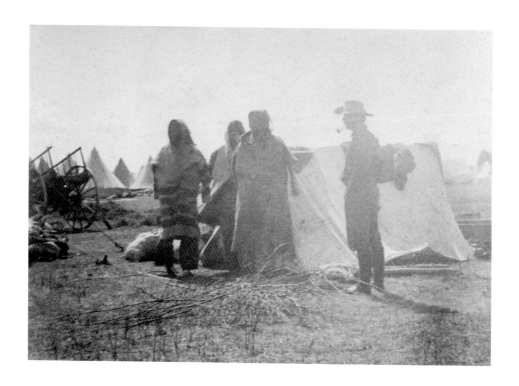

640
Church Service.
C-018938

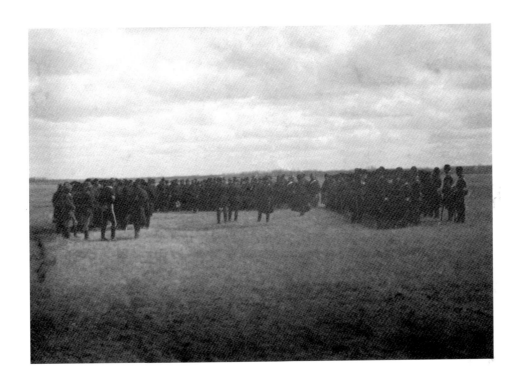

698
Scalping.
C-018947

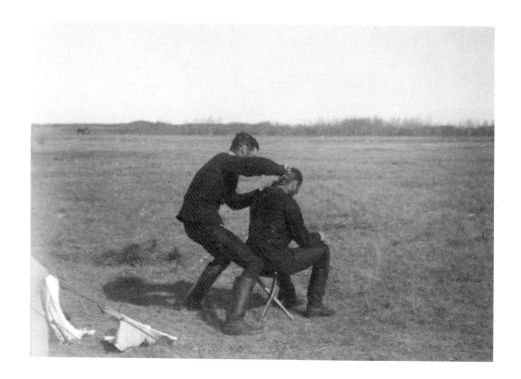

669
French and His Men.
C-018942

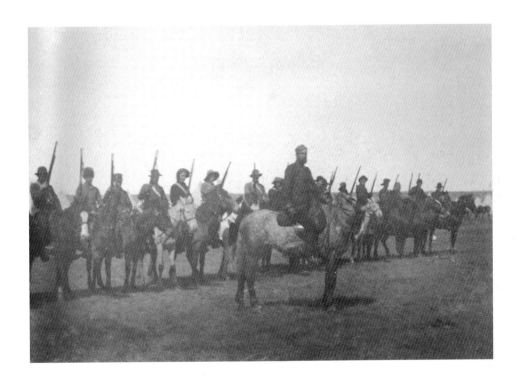

695
Gun Pit.
C-003461

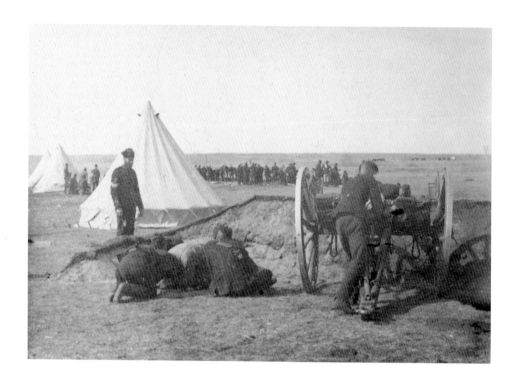

636
Scouts on Lookout.
C-017611

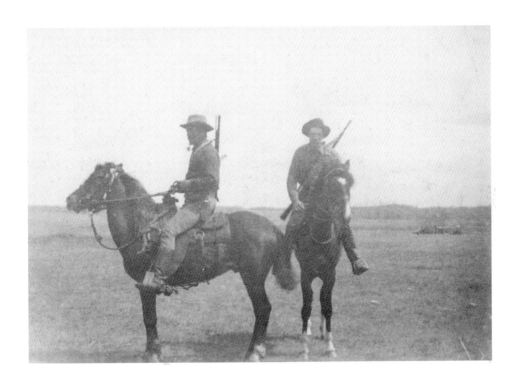

643
Our First Check, Fish Creek.

C-004524

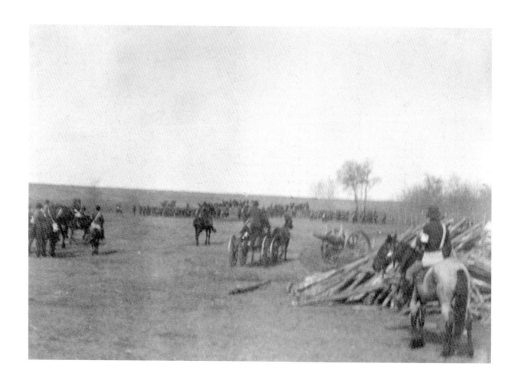

629
The First Fresh Meat (Loot).
C-018109

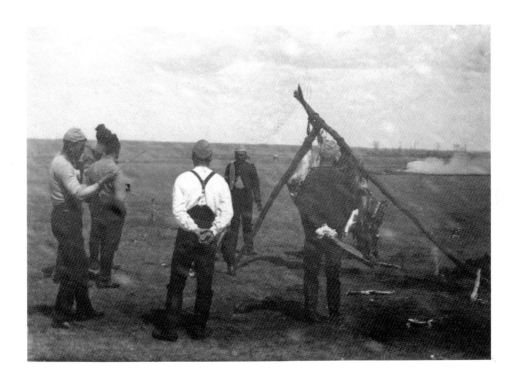

727
Boulton's [Scouts].
C-018964

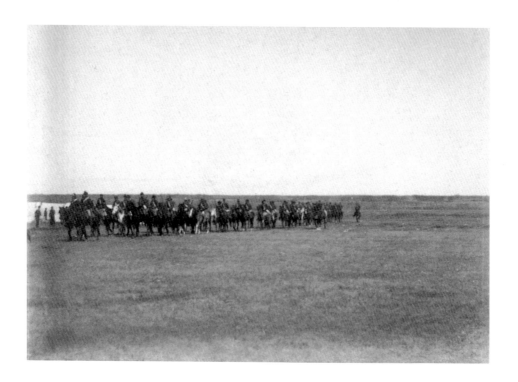

728
"C" Company and "A" Battery.
C-018111

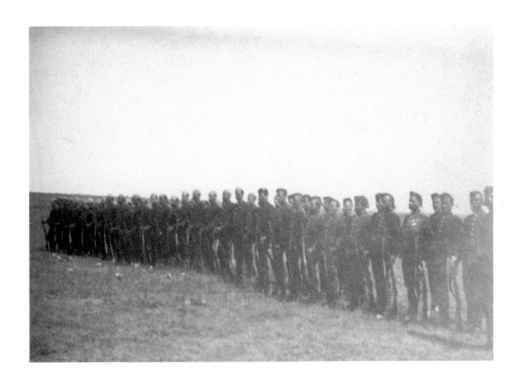

627
Boulton's Scouts.
C-18934

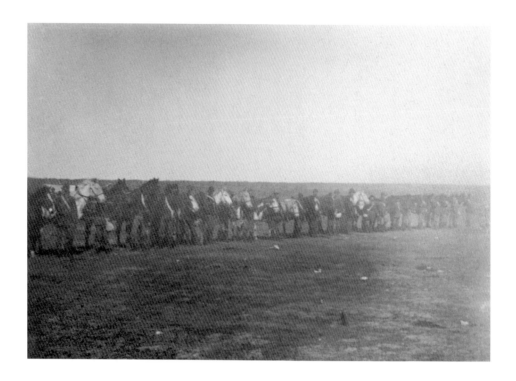

619
Boulton's and French's Scouts.
C-018931

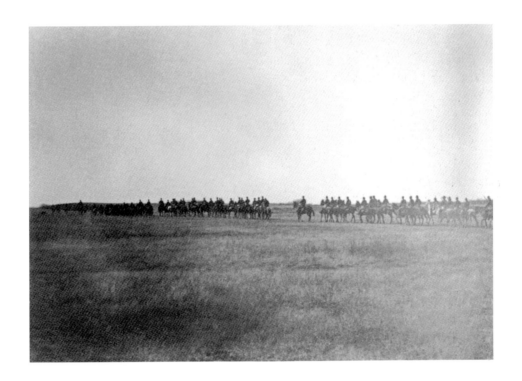

624
Our [Gun]pits on River.
C-018933

641

Lord Melgund and French Advancing to "Gabriel's Crossing."

C-018939

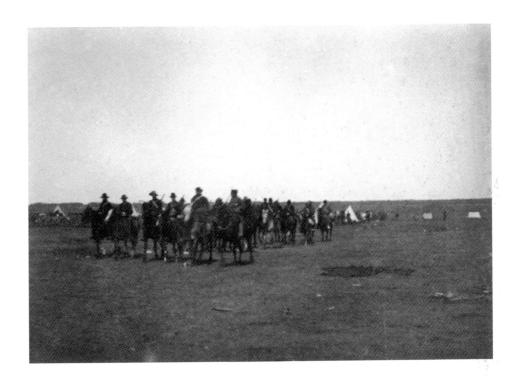

661
Old Howrie.
C-018940

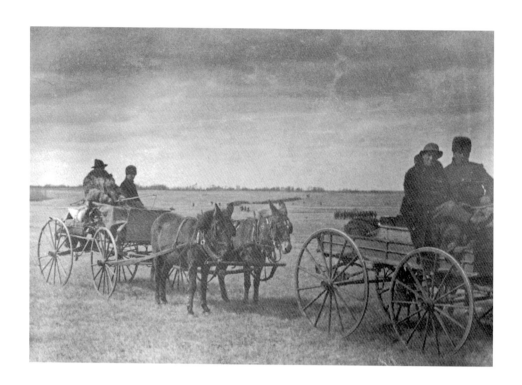

672
Northcote Before Batoche.

C-003447

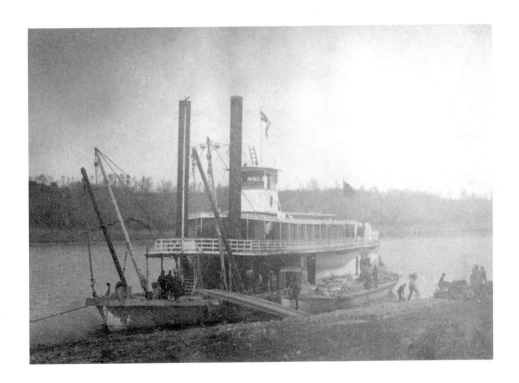

647
First Sight of Batoche.
C-003465

648

Opening the Ball at Batoche.

C-003464

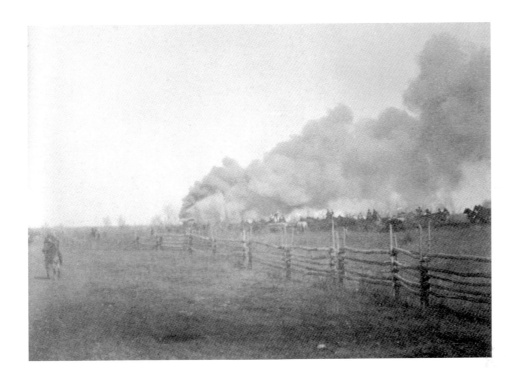

671

Batoche from Where Lt. Fitch Was Killed.

C-003452

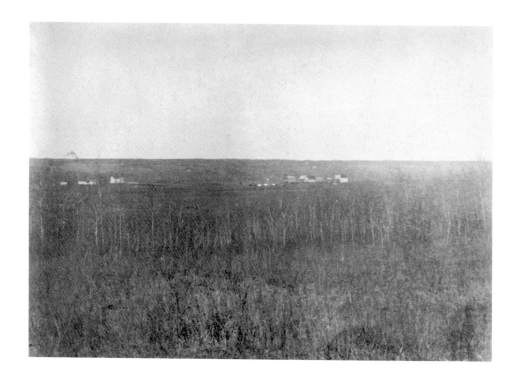

646

Asleep in the Trenches.

C-004522

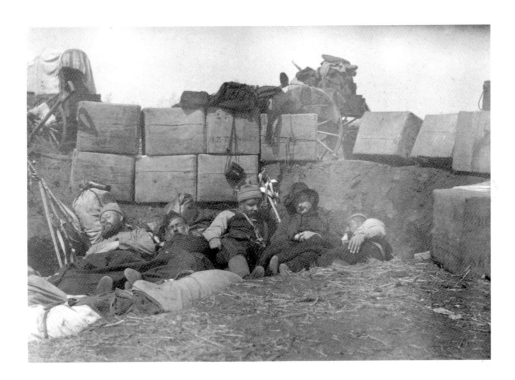

649

General F.D. Middleton Meeting Priests.

C-003462

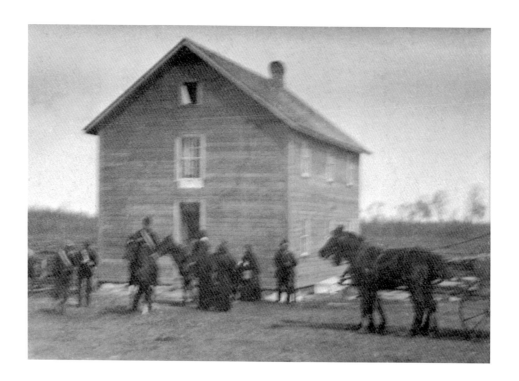

642
The Zareba.
C-003454

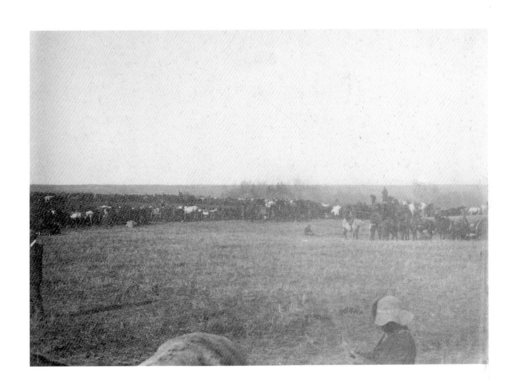

616

Shelling Batoche, the Last Shot Before the Attack on the Guns.

C-003463

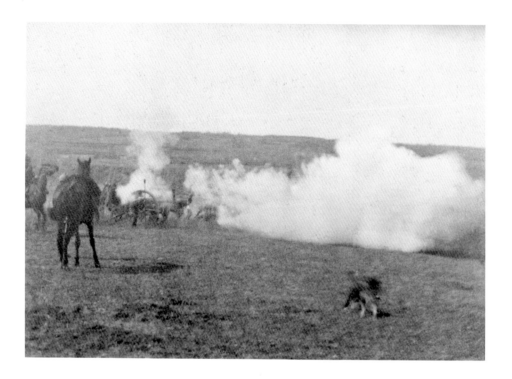

681
Shot Dead.
C-003451

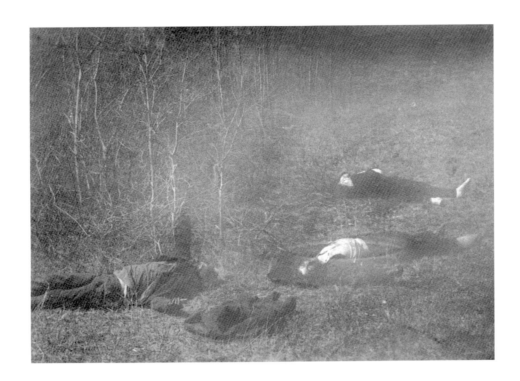

680

How They Left Their Pits.

C-003449

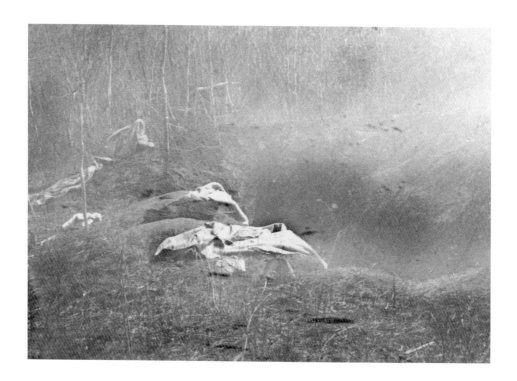

676

He Shot Captain French.

C-004523

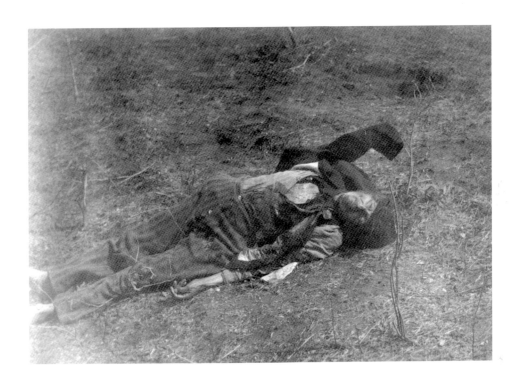

683
Steamship *Northcote* after Batoche.
C-003448

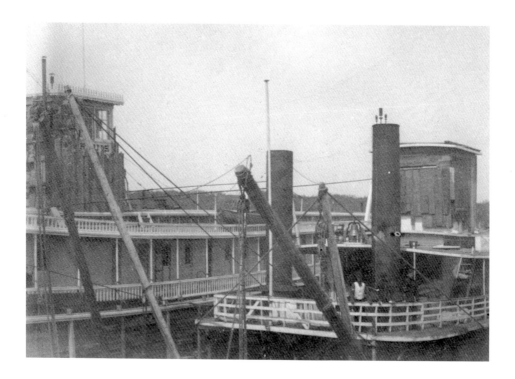

711

Louis Riel, a Prisoner in the Camp of Major-General F.D. Middleton.

C-00345053

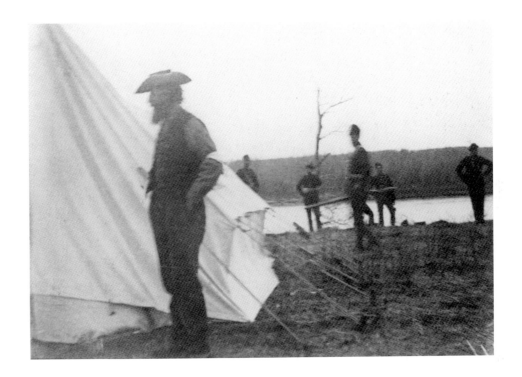

713

Camp at Gardepuy's Crossing.

C-018953

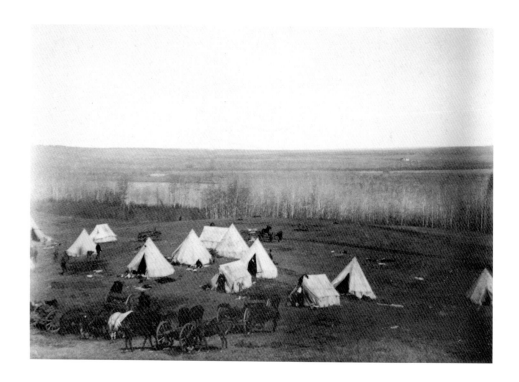

714
Breaking Camp at Gardepuis.
C-018108

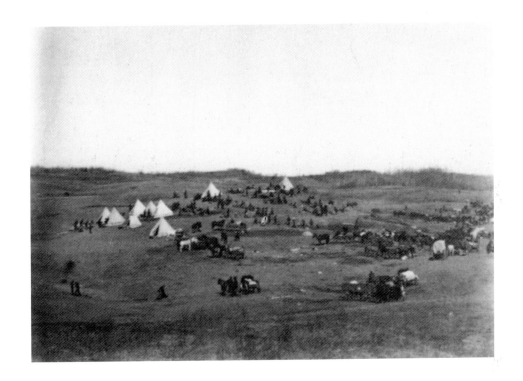

712

Navigating the St. Lawrence.

C-018952

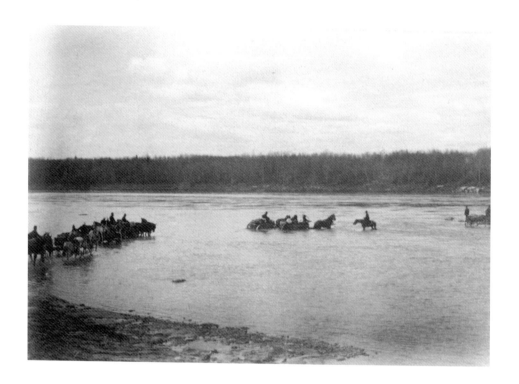

722

Moosomin, a Loyal Cree.

C-018960

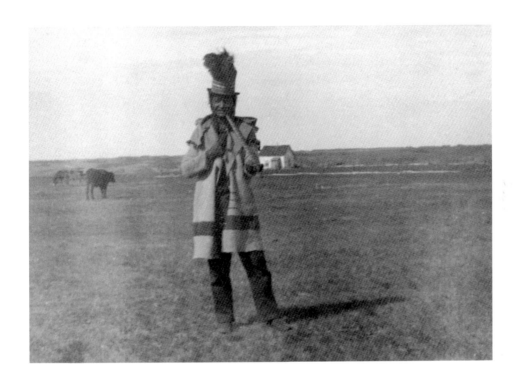

706
Ferrying at Fort Carlton.
C-018948

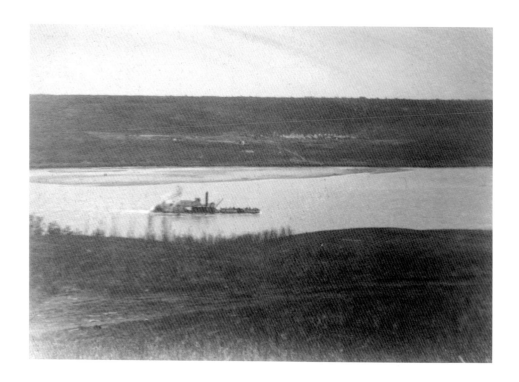

707
On the Ferry.
C-004592

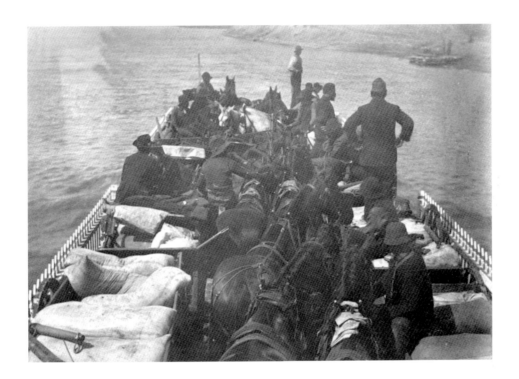

717
Chipweyan Camp.
C-018956

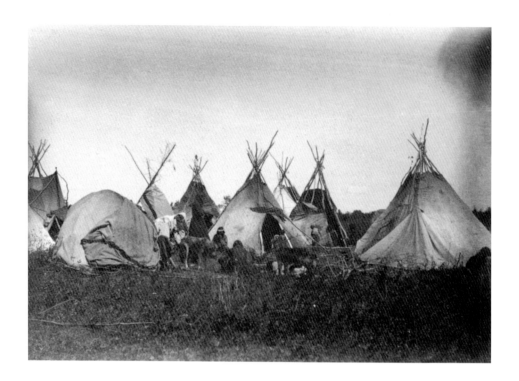

716
Chipweyan Camp.
C-018955

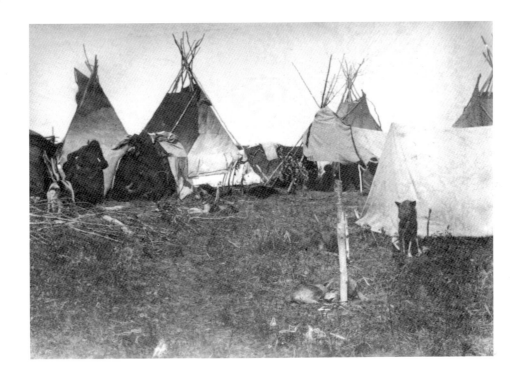

715
Pow Wow with Chippeweyans.
C-018954

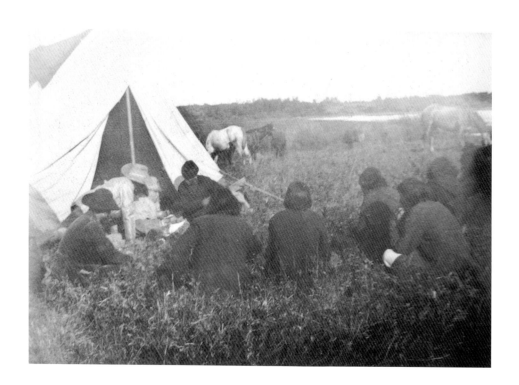

709
Beardy Trail Pow Wow.
C-018951

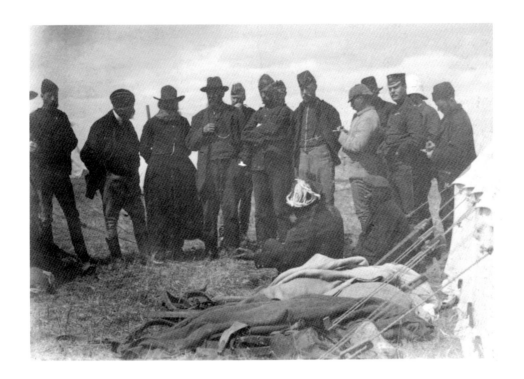

710
Pow Wow with Beardy.
C-018950

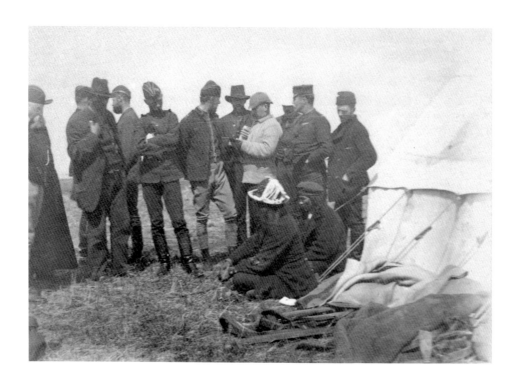

708
Beardy and His Chiefs.
C-018949

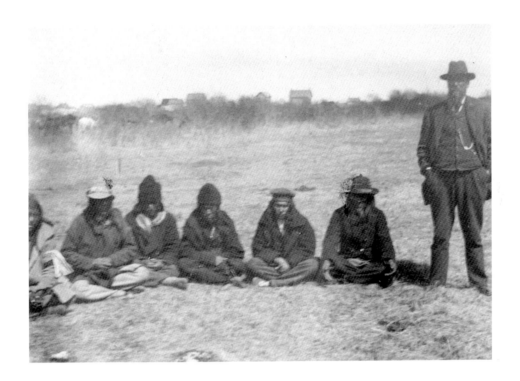

720

On the Big Bear Trail.

C-018958

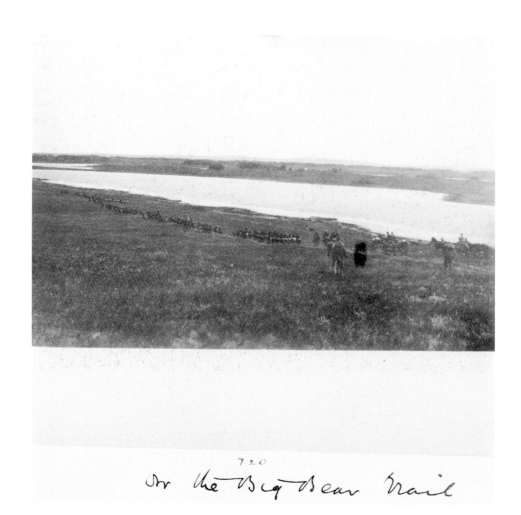

719
Miserable Man Surrendering at Battleford.
C-017374

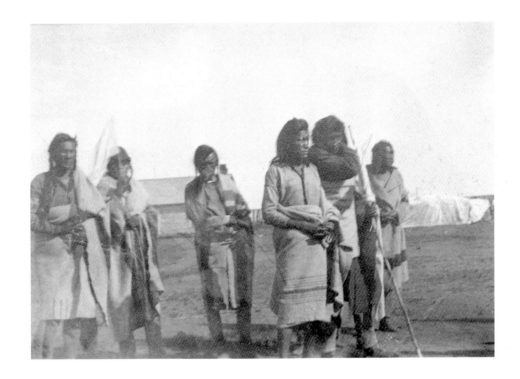

725
Mrs. Miserable Man.
C-018963

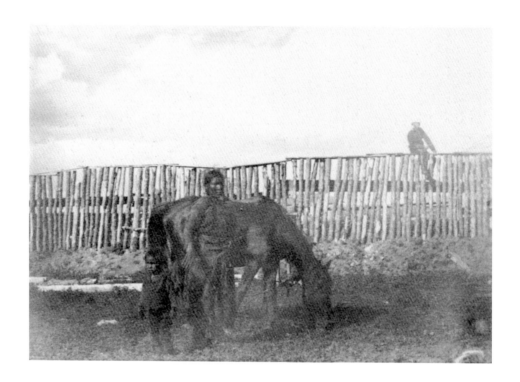

703
Poundmaker, a Cree Chief.

C-004593

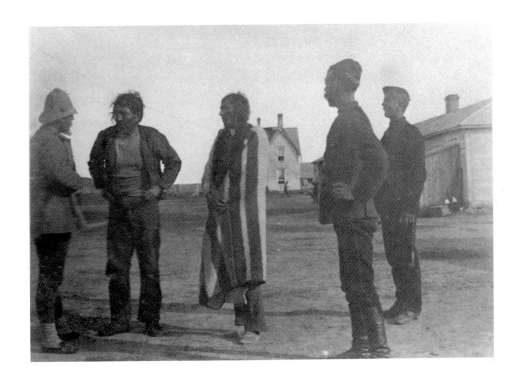

704
Strawbenzie and Poundmaker.
C-004594

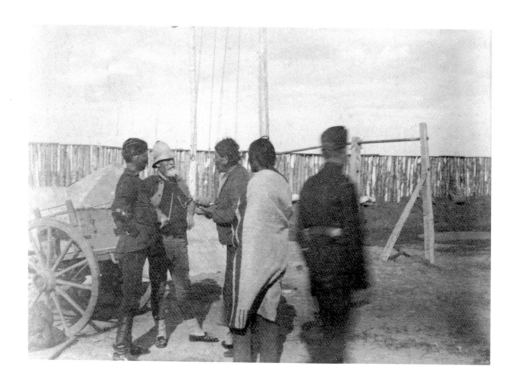

705
Poundmaker and Chiefs.
C-018869

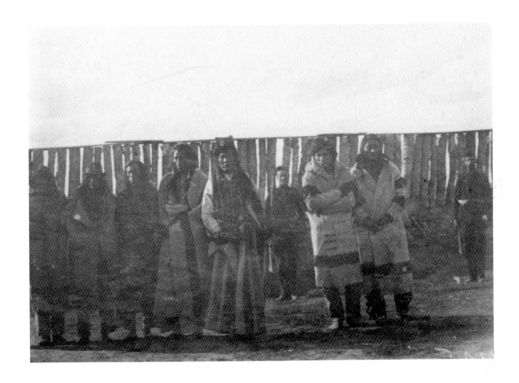

718

First Ford, Loon Lake, Scene of Steele's Fight.

C-018957

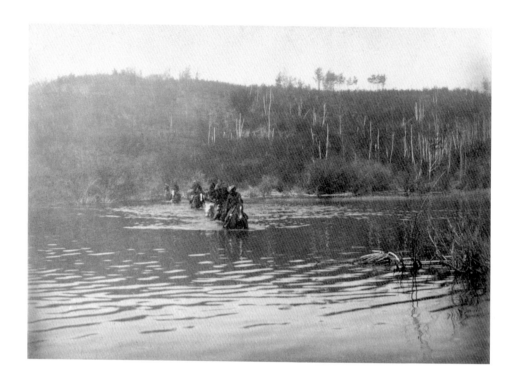

721
Second Ford, Loon Lake, Where Gen. Middleton Turned Back.
C-018959

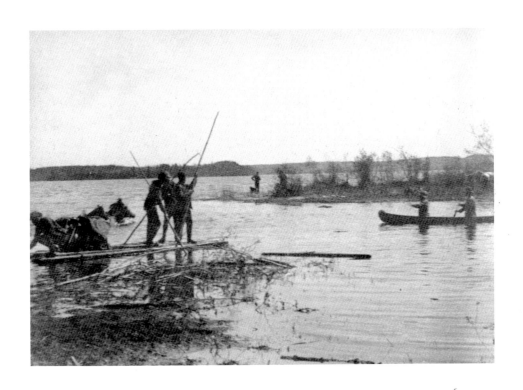

723
Second Ford, Loon Lake.
C-018961

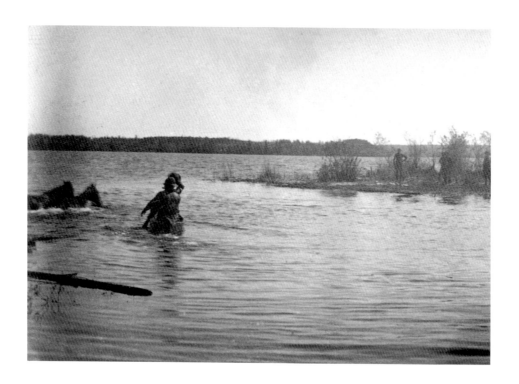

724
Second Ford, Loon Lake.
C-018962

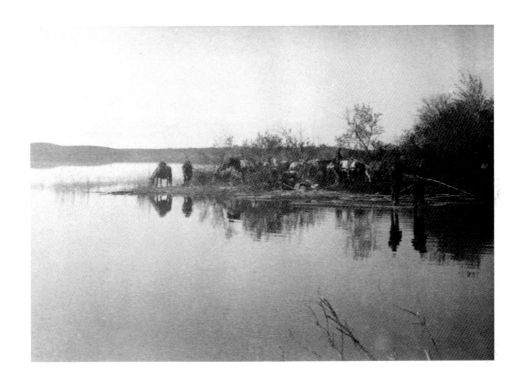

Appendix A

Lines of Skirmishers under Fire.
Glenbow Archives NA-363-14

Horses, Transport Teams in Camp.
Glenbow Archives NA-363-15

Photographs taken by Peters not included in the
family album, but part of an album held by the
Glenbow Archives, Calgary.

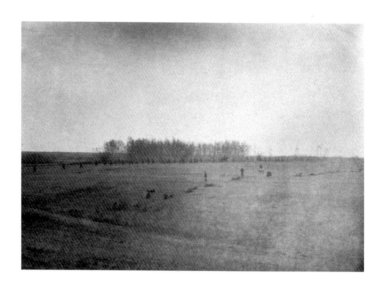

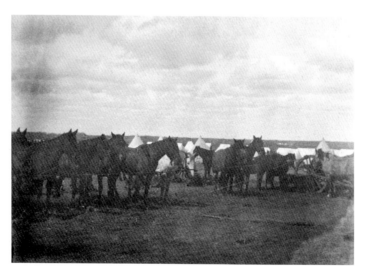

Transport Teams and Men on the March.
Glenbow Archives NA-363-16

General F.D. Middleton and Wounded Men in Camp.
Glenbow Archives NA-363-25

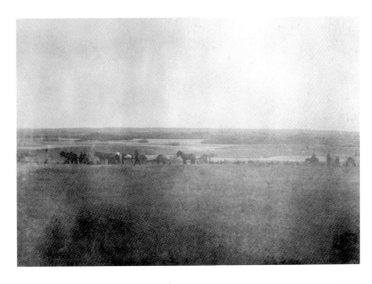

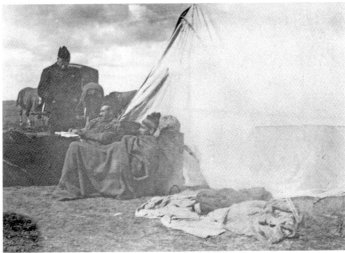

Appendix B

Sentry Box, Prince Albert.
C-010485

Camp, "B" Battery, Prince Albert.
C-018945

Photographs credited to Peters, but actually taken by
Lieutenant William Imlah (as described in the family
album). Held by Library and Archives Canada.

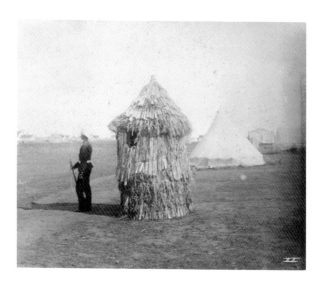

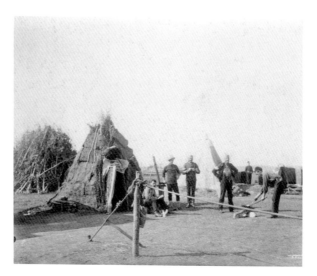

Crees at Prince Albert.

C-017610

Mess Tent, "B" Battery, Prince Albert.

C-019504

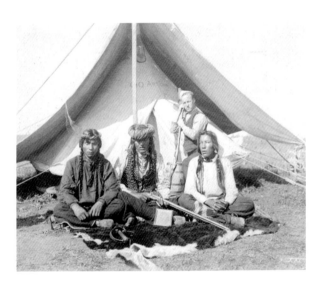

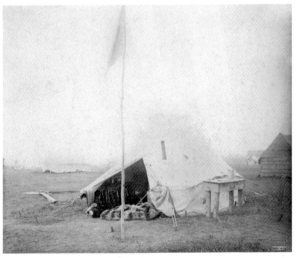